CREATIVE THURSDAY

Everyday Inspiration
to Grow Your
Creative Practice

Marisa Anne

NORTH LIGHT BOOKS
Cincinnati, Ohio
createmixedmedia.com

Contents

I Believe Everyone Is Creative
Hello there! Welcome to the beginning of this book.

If you're like me, you contemplate the decision to buy a book through a series of moments: first by the design of the cover, then by the title and then by the book's introduction.

(Now I'm feeling the pressure as I write this introduction to you.)

Where do I begin? There is (always) so much to share with you. And yes, I cannot forget that an entire book follows this intro.

Also, if you are like me, some part of you simply intuits which books you must have the instant you come across them. Those are the ones that you barely even have to crack open the cover and you already feel good, just by sensing what they have in them. If you've picked up this book, it is my hope that what you hold in your hands is making you feel that way.

I saved the writing of this introduction until the very end of the writing process. Seems counterintuitive? I mean, the introduction really should come first, yes? But that's not always how it works. Sometimes you start with an idea, maybe even a well-thought-out plan, but in the end your creative projects (and your life) still become what it is they want to become. And when you trust this process—that is, when you begin to see the beauty in the adventure—ideas flow and doors open.

So, although I had a plan for this book, I also had to be open to what it wanted to become and then return to write about it.

I tried out a lot of different paths to get to this very moment where I'm writing these words to you. I had many moments when I wasn't even sure that I knew what my path was. I just knew that my love for creativity was always calling me forward. Writing this for you now, it all makes sense. It always does. What I didn't see initially was that all of my choices to pursue a creative life were actually perfect and always right on schedule. If I hadn't veered in so many different directions, accompanied by this intense longing to find my life's work—my calling, I would not be nearly as emphatic about sharing my story with you. Wherever you are on your creative journey, in this very moment as you read these words, you are right where you are supposed to be.

Learning about others' stories inspired me forward and saved me on those days when I felt completely lost and disheartened. Somehow I knew that when I reached the place I was hoping to find, I would, without a doubt, share my story with the hopes of inspiring others in the same way.

With that said, this book isn't all about my personal journey. Of course some of my personal experiences are woven in to illustrate specific examples, but more than that, this book is written for you. It is written to encourage you to trust yourself, to listen to your voice and to follow your heart—wherever you are on your creative journey, whether you are just beginning or well along the way.

I want to help you discover what you have been searching for, how to trust your creative voice and most important, how to trust yourself. And don't let me suggest that I have this all figured out by any means, because what you'll hear me say over and over is that everything is constantly evolving. But I will also say that once you are comfortable on that path, even if you get off track, you will always know how to find your way back. Having a sense of where you are going and why you are going there will give you the freedom to keep exploring joyfully.

What I want most is to be your companion along the way—your trusted, kind, honest, genuine, and unconditionally loving friend, always cheering you on.

Even though I will go into more detail in this book about the story behind the title of *Creative Thursday*, I can't complete this introduction without answering the two questions I hear most often: "So what is Creative Thursday?" and "Are you only creative on Thursdays? What about the other days?"

To which I answer: What started out as one day a week—Thursdays—set aside to be a bit more creative while working a 9-to-5 job, Creative Thursday has become a full-time business featuring my art and creations or, as I like to call it, a dream come true.

And yes, I am now creative on more days than Thursdays.

Which brings me to my final point about why I started this introduction with the statement "I believe everyone is creative."

First, it's what I believe. Second, when I tell someone I am an artist, I cannot begin to tell you how many people proceed to tell me that they are not creative. I always immediately respond with "Yes you are." Because you are; we all are. Creativity isn't just about making art; we experience it every day. It's up to us to decide how much we access it.

So whether you choose to make creativity a priority just one day a week or all seven, personally, professionally or both, what I know is that there's nothing better than the fulfillment that comes from being creative.

And now it's time to begin this book. Sharing the original tagline that accompanied Creative Thursday feels like the perfect place to start.

be free, be happy, be true—be creative every day, especially Thursdays!

CHAPTER ONE

Setting an Intention

For months a partially finished canvas sat on an easel in my studio. I had been trying to capture some beautiful star luminaries that hang every holiday season at a well-known outdoor shopping area, called The Grove, here in Los Angeles. I kept trying to render the lights exactly as I had seen them against the backdrop of a gorgeous dusk sky . . . with no luck. As much as the imagery of the sparkly lights inspired me, painting them did not.

Something about that unfinished painting sitting for months on the easel felt even more daunting than an empty easel. Why could I not finish the piece? I couldn't because it had been so long since I painted that I didn't even know how to begin to express who I *now* was in my work.

Several months later, after an eight-hour drive through Utah and Nevada, I took out a blue tarp, laid it over my bed, grabbed a canvas and some paints, and started painting. I didn't stop painting for six more hours. Painting after painting poured out of me, as if my creativity had been pent up for years.

On that drive back home from my third visit to the Sundance Film Festival, I had been captivated by the most gorgeous sunset over the hills of Utah (something about those skies)—so much so that I *had* to paint it. And I wasn't about to try painting it standing at an easel; I somehow knew that would stifle me. (This is why the tarp was sprawled across my bed.) But I did something else different this time as well. I didn't have a photo of the hills to refer to, just the image in my mind, so I decided to paint *my interpretation* of it and not an exact replica.

This concept was something I'd forgotten I had in me. In my interpretation, all of the hills were different, beautifully saturated colors, and the sky was not a typical "sunset sky." Yet the painting captured the feeling of that moment for me. It was like I had opened up a

dam, and now it was all I could do to not paint everything in sight with my newly discovered "interpretation approach." It was not until I painted those hills that I got a glimpse again of my true voice as an artist.

Between the ages of five and ten, when creating tiny character and animal drawings was a favorite expression, that true voice was much more present. When I was a teenager, I looked at photographs and attempted to re-create them exactly as I saw them. That is how I learned to paint. I learned to see. I learned to see the subject matter I was painting as colors blended together to create an object. I learned to work with watercolor and acrylic paints, pastels and different lead weights of pencils.

Having drawn and painted throughout my childhood, I still cannot remember the exact moment that

I began to paint so realistically. At one point I may have come across a photograph I loved so much that I felt compelled to paint it. I started spending many weekends painting at the kitchen table.

As I took art classes in high school, my confidence grew. I was inspired to take my art further and develop a portfolio of work to present for acceptance into the advanced art class. I was rejected. My first door shut on a path that I knew was meant to be mine.

I put my paints away for a while, but my love of art never left me. In my early curriculum at college, I took as many art classes as I could, but did not have the courage to choose fine art as my major. First, I thought it was unlikely that I could make a living as an artist, and second, I am sure that the aforementioned rejection kept me from believing that I was good enough to become an actual art student.

I found advertising in the Communications College and loved it. I continued to take art classes alongside my advertising major and I had moments of pure fulfillment, using my knowledge of art to design ad campaigns. This was at a time when computers were just entering the world of graphic design. (Remember those days?)

When I left school, I had my bachelor of science degree in advertising and my outside concentration in art. I went to work immediately as a graphic designer. In fact, in my second job out of college, I worked in a room full of art-school graduates. So much for my false idea about not being able to make a living as an art-school graduate

Of course looking back now, I can see that it all worked out perfectly. As an entrepreneur selling my own creations, a day doesn't go by that I'm not appreciative of my degree in advertising and all the knowledge that came with it.

Eight years drifted by between those early jobs and that day I sat down to paint on the bed with my big blue tarp—eight years and *one small intention*, to be exact.

What Does Setting an Intention Mean?

my vision

Maybe you have heard of this concept? The one that seems to be popping up everywhere in our vernacular—*setting an intention*. So what does it mean exactly? And how do we do it? How do we follow it?

When do we follow it? When an approach is somewhat ethereal, I find that starting with an actual definition can help. A definition of *intention* is: "A course of action that one intends to follow."

Visit www.createmixedmedia.com/creativethursday for more creative ideas.

Setting an intention is powerful, for sure. I am sitting here writing a book and sharing it with you because of an intention I set eleven years ago—somewhere in that eight-year span between my first job out of school and that blue-tarp painting. Most definitely in motion for quite some time, there was still a moment when I knew a specific intention had been set.

It was simple, really. Even though I was working in the creative field of interior design at the time (following my time as a graphic designer, I decided to return to school to pursue an entirely new career as an interior designer), I still longed to be more creative.

I had an entrepreneurial friend who had recently sold her ceramics business and had also just become a mom to twins. She too was craving more creative time. We were getting together every week for a visit when it occurred to us that we could start by focusing our visits on how we were going to add more creativity back into our lives. We were meeting on Thursdays, which has always been my favorite day of the week,

so I enthusiastically started referring to this time as Creative Thursday.

In the early days of Creative Thursday, we didn't actually craft or make anything—instead we drank wine. But between pouring the glasses of wine, we talked at length about all of our creative plans. Those moments, for me, were exactly when the seed of my creative life and business were planted.

That's how it works with intentions. Sometimes you are putting them into place (during a chat over a glass of wine) without even realizing it—almost by default. When you look out into the world, ponder choices about what you prefer and make decisions about where you want to go, intentions are being set! But here's the part that we often miss: It's not enough to just set an intention; we have to *believe* in our intentions, and we have to follow through.

An intention can be as simple as planning to have a good day or it can be as complex as following a life-long dream.

Inspired Action

Visit www.createmixedmedia.com/creativethursday for more creative ideas.

So how, exactly, can intention setting help you be more creative in your life? A good place to start is by using the practice of "inspired action." This is different from "regular old action." Take a look at the list that follows, remembering the points about *breathing* and *having fun*. And I re-emphasize these points because if you are like I was when I was starting out on this journey, you might forget to do both sometimes. These steps should be done in stages at a pace that feels comfortable to *you*. You don't want to use a slow pace as an excuse to keep resisting your creativity, but you do want to allow yourself the time you need to develop answers to questions and for inspiration to come in.

Is there something you want in your life?

- Intend it
- Believe it
- Commit to it
- Follow through with *inspired action*
- Trust when you can't yet see how it is coming together
- Expect it to happen
- Breathe often
- Have fun
- Appreciate the moments on the way to where you are going. (You don't want to miss the magic while it's happening.)

Choose a sunny spot

Visit www.createmixedmedia.com/creativethursday for more creative ideas.

The fourth point in that list instructs, "Follow through with *inspired action*." So what does that mean, exactly? There are two halves to that equation.

First, be clear about what you want.

Recognize (and let it be OK) that intentions are often first born out of feeling like something is missing and/or knowing what you *don't* want. Be willing to ask yourself the sometimes tough questions about what you truly want in your life. Be willing to look at what isn't working and what is.

This practice of deliberately setting intentions is about a willingness to take the time, take a moment, take a breath and look at where you are in relation to where you want to go.

Second, believe that you are creative.

As I mentioned in my introduction, often when some-one sees what I've made, they say to me, "Oh, I wish I were creative." And every time I say in return, "But you *are* creative."

Somewhere I heard that when a group of five-year-olds is asked to raise their hands if they can draw, all of their hands go up in the air; but when asked that question later in life, very few, if any, hands go up. I'm not sure what happens for each of us between the ages of five and "sometime later," but can we agree to ignore the standards of what society defines as being artistic and get back to creating already?

If you've resisted your creativity, you can set quite a lot into motion just by taking these first two steps. This might be a good time to remember to breathe and just be, and see what comes up for you. For instance, you might begin to think about what your favorite medium to work in is. You might think about what inspires you and what your favorite subject matter is. You might think about what you enjoy most in your life, along with where you are and what you are doing when inspiration typically floats in. You will be open-ing a door, one that you may have closed for a while simply because you didn't believe. And this is where the power of intention comes in; it opens the door to what's next.

Moving Through (and Accepting) Resistance

A funny thing happens when you set an intention; sometimes you meet resistance.

I actually started writing the book with this chapter. Why? Because starting a book is bringing me very up-close-and-personal with resistance once again.

Do you know how many other things I could and should be doing right now? Do you understand that my e-mail is calling to me and my cat is meowing for me to open the door so she can go outside?

No. No. No. I'm sitting down to write this book.

But wait; let me make a cup of tea.

Oh, and wait. I see that the breakfast dishes need to be done And did I make the bed today? Are there phone calls I need to return? The plants need to be watered. Sean and I really need to meet and plan out our week along with our meals, and I need to go to the store . . . we should probably revisit our entire life plan while we're at it

Oh! I'm feeling inspiration to *paint* right now! (Yes, even other creative pursuits and passions can come up as resistance—always at the most opportune moments.)

No. I am writing this book now. *Right NOW*. No excuses, no more getting everything just right and organized and planned before I sit down to write this book that you have in your hands. If you do indeed have a book in your hands, then I did it. I made it past the resistance and not only wrote, but completed an entire book. OK, I'm excited now! I can visualize you with this book, getting inspired, creating beautiful things, tapping into more moments of pure joy, and that vision alone will carry me through any moment of resistance that probably will visit me again through this process. (Which it did. You should have seen how many days I procrastinated reviewing the first edit.)

Does any of this dialogue sound familiar to you? Have you had similar conversations, only to find yourself waiting until a better time comes along to get started? But then when that "better time" does come along, you're too tired to do one more thing that day?

Because resistance is guaranteed to resurface again and again. It's almost as if we have to learn to make resistance our friend.

So here I go—me and the laptop and, oh, OK, a cup of tea. A writer has to have a hot cup of tea while sitting in a comfy chair, listening to inspiring music, with maybe even a candle lit or incense burning in the background (whatever works).

Sometimes all it takes to get past initial resistance is to create a special and inviting ritual to get you started. Just don't use having to figure out said ritual as one more reason not to get started. I know making a cup of tea is an art that can be perfected, but it's not the reason you should use to keep you from creating.

There are days when I literally have to take my arm and gently push away piles of papers on my desk, carve out a small space for my wood panel to reside, grab my pencil, eraser, paints, brushes and paint tray to start painting before I even take my morning shower, pour a cup of coffee, have breakfast, check an e-mail, make a bed or speak to anyone. Sometimes I must decide to paint *first*. And that's just all there is to it! Easier said than done some days, I know.

If you are at all like me—someone who loves a clean, organized space accompanied by a properly planned and paced life and business; who also likes her inbox to be as close to zero as possible (plus my fridge stocked, meals prepared ahead of time, my relationships feeling harmonious and my errands run, all before I create)—then you might also find it rather challenging to close your e-mail, turn off your phone and use your arm to push away papers and projects to get to the creating.

If creating feels like breathing and an absolute necessity to your joy and fulfillment in life (and you get very cranky when you don't create), then you *know* how important it is to let creativity take priority—dare I say, above all else—on some days.

I know that often, what stands between you and your creative time is called life, and life is important. But much of life can also be disguised as resistance that comes between you and your opportunity to

Visit www.createmixedmedia.com/creativethursday for more creative ideas.

express the fullness of who you are becoming—the person you are meant to be.

The amount of things the average human being is expected to keep up with in life, and the pace with which we are trying to keep up with all of these things, can feel extreme. So as you can see, tending to your creativity is more than just making time to create art; it's about making time for yourself. If we are not caring for ourselves, there is no energy to keep up with all of the expectations anyway, so why not let tending to

your creativity be one of the very best reasons to take excellent care of yourself?

This world is not going to slow down and wait for us, but we can decide to be mindful and deliberate about how we choose to live within it, the pace we want to go, what we choose to prioritize in any of our 24-hour days. Which brings me back to this particular 24-hour day—the one in which I started this book.

What I decided to do this morning is step from bed right to writing. Without this decision to move past that initial hurdle of resistance, it is possible that there would be no writing today. At this stage in my life and career as a professional creative, there will always be something that can take the place of my creative time, and it will always seem urgent and more important. I have learned over time that my most important role is just that: to be creative. That is my gift and where I find fulfillment. That's why I set aside one day a week so long ago. To lose sight of this now would be to deny the very intent I started with.

Are you denying any part of your creative expression that is calling you? Denial is a powerful form of resistance. You can always come up with some pretty convincing arguments for why *now* is not the best time to be creative. The best way to tackle this is to be honest with yourself about the reasons for putting off your creativity. With honesty and awareness comes the beginning of change.

One would think that I, being a creative professional, would have this "moving past resistance" thing down. I create so frequently and for my work that it seems as if I could seamlessly transition from one activity to another, always knowing when to make creativity the priority. And I do know this—intellectually, that is. My mind still encounters that same resistance it did when I first started. The difference is that now I know how to recognize it, accept it and keep creating anyway. The difference between one who creates and one who does not is the ability to move past resistance, or, as Julia Cameron put it in her book, *The Artist's Way*, "Artists are just people who have learned to live with self-doubt and do the work anyway."

Start With Starting

Visit www.createmixedmedia.com/creativethursday for more creative ideas.

So we're aware of it; now what? What's really going on with resistance? On the surface, resistance refers to everything that gets between you and your creative pursuits. It's our fears—especially the one accompanied by that little doubting voice (or inner critic) in your head telling you all the reasons why you're not good enough and why you should not create in this moment. (If you are someone who does not experience that voice, you are lucky and you are in the minority. Put this book down now and go make something!)

If you know the voice I'm talking about, then come on. We are moving through resistance, you and I. (By the way, one of the best books I've read focusing almost entirely on this subject is called *The War of Art* by Steven Pressfield.)

Beginning a project is sometimes the toughest hurdle to overcome. We always refer to this moment as staring at the blank page or the blank canvas. Those wide-open spaces can be intimidating for many of us. Or! They can be this exhilarating opportunity to begin again. In general, as a society, we adopt the notion that accomplishment—specifically, completion of what we start—is the key to success and fulfillment. We are not usually encouraged to consider that the fulfillment also lies in enjoying the journey, not just the destination. If the destination is the final prize, you can see how the process of starting might be met with resistance instead of enthusiasm every time. But societal expectations are not a good enough reason to keep us from starting . . . so simply begin.

Be willing to not make a very good start.

Or, dare I say, to make a bad one. For the record, I tend to think that every single thing that anyone makes should be treasured, so it's challenging for me to say "bad start."

I live with Sean, a wonderful person and a fantastic teacher to boot. A former Groundlings Theater main company member, he teaches improv and sketch comedy writing. Needless to say, he's a very skilled writer—especially when it comes to comedy. Imagine the pressure to not only write something, but to write something funny. You can see how you might never put those first words down on the page because your mind will most likely tell you that, "It's not funny." This is why he always encourages his students to just write—write something. And he tells them to "be willing to write something bad." Don't look for it to be good, or even close to perfect, right out of the gate.

Fear, self-judgment and criticism make everything more difficult, especially the possibility of genius coming through at any time in the creative process. Because it could, you know. You might get some genius channeling right at the start of a project. But by not putting extra pressure on yourself at the beginning, you will not only get started, but you might give that genius a shot at coming through. And don't forget to think about why you love creating to begin with. Shouldn't we be just as excited about that first word to hit the page or a burst of color touching the canvas as we are about a finished poem or painting?

Once you get started, it's much easier to keep going.

Remember from science class the definition of inertia: *An object at rest tends to stay at rest, and an object in motion tends to stay in motion.*

We are after the latter here. Then, if you are like me, once in motion, you don't want to stop at all—you are in "the zone." Clearly this is not a likely possibility

for me with this book, though I have heard of writers knocking out entire screenplays in three weeks, or musicians who go away and rent a cabin, staying there until their next album is completed. It's good to know it can be done. And if you have the opportunity to finish once you've started, or to put all of your life's focus on only one project at a time, seize it and run like the wind. But if you can't, that's OK. A book is written one page at time. A painting is painted one stroke at a time.

Visit www.createmixedmedia.com/creativethursday for more creative ideas.

A dress is sewn one stitch at a time. And eventually those pages, strokes and stitches add up to a completed piece. If you are like the majority of us who have life going on around, above, below and between our creative projects, learning to squeeze creativity in anytime you can get it is probably the best place to start. This is why learning to get over the initial resistance is such a valuable skill to have.

If you do have to put down a project, it should be easier to return to it, now that you are beyond that initial start. But it does not mean that you won't encounter resistance again when you do decide to return.

What happens then? How do we move past resistance again? This is where a little more in-depth understanding of what is causing your resistance will come into play, as well as the opportunity to learn about what processes and disciplines of creating you enjoy the most.

When the determination to be resistance-free creates more resistance.

Can I just tell you how many things came up this week in what felt like a response to my firm dedication to get this book started? My car battery decided to die; my usual marital bliss fell off balance; invitations to last-minute fun events that I just had to attend arrived . . . the list goes on and on. Oh, wait; it's life again. Sometimes there are those weeks when life seems to be more hectic than usual *right* when you decide once and for all you are going be more creative (or start writing a book, for example). And no, resistances are not always negative events. Busying yourself with social engagements can definitely be a form of resistance. And your mind says, "But yes! I have to have some fun and visit with friends." And of course you do. For me socializing plays a very important role in my inspiration. But I still had to decide that making time for writing was first on my list that week.

In the end, it all worked out. My car is up and running again with a new battery, marital bliss has been restored and I made it to my friend's new album release party. Just know that it can be totally normal to feel extra resistance at the very moment you decide to commit to that intention. Sometimes it feels like life is testing you to see just how committed you are to your new endeavor. Those are the very moments when it is

most important to stay on course, because if you can stay focused when life is most hectic, imagine how much easier it will be when calm has been restored. Take a deep breath, take it all in stride and then show your intention that you are committed.

Engaging With Your Fears

Consider your fear of failure.

Although I have written since childhood—and over the last five years, I have kept a consistent blog, written courses, marketing materials, a children's book and even a small e-book—I have not written a *book* book. My first thought says, can I write an entire book? I mean I really haven't ever written one . . . So many words I am expected to share. Do I have that much to say? If it turns out that I do have that much to say, will I be able to say things in an eloquent and entertaining way?

What if I fail at writing a book? When you break it all down, that is what I am afraid of: Failure. But that is a completely normal part of the creative process. There's always a risk of failure in whatever we create when we decide to share it with the world. We need to redefine failure and make a decision that no matter how something is received, we are proud of the work we accomplished.

When you start digging a little deeper into the meaning behind your resistance, as I shared earlier, fear is often staring back at you—more specifically, self-doubt, fear of not being good enough, fear of failure. I'm certain that this is exactly what stops many of us when we are young. When we're very little, we are blissfully unaware of expectations of who we're supposed to be or how what we express and share with the world is supposed to look. We live and create with more abandon, joy and more naps.

Then we become aware of societal expectations, set up by someone, somewhere that is now the definition of what is the acceptable norm. I don't know who that someone, somewhere is, and I don't know why we are all trying to live up to his or her standards.

Let go of the need for perfection.

Remember what I said before about the willingness to make a bad start? Well, a willingness for a completed project to be less than perfect is also needed when trying to move through resistance. Many times we aren't willing to start a project because we are afraid it will not be perfect immediately or maybe ever.

First of all, I want to ask, what is "perfection" anyway? Who decides what is perfect? I know some art historians and art professors might disagree, but I believe that when it comes to art, both in what we observe and what we create, we should be the ones to decide what is perfect. And let's never forget: Art is subjective. Which means that when we decide our creation is perfect, then it is. Do you know how much freedom there is in simply deciding when a creation is perfectly finished? We all know how much endless tinkering and refining can be done within any and all creative practices.

So as I write to you about resistance, I'm realizing that part of my own resistance in writing this book is the challenge for me to not want to refine it endlessly. I'm not used to working on a project that takes more than a day. I'm not used to having the opportunity to

craft and refine something further over a long chunk of time. Instead of working from one burst of inspiration that I use to carry me all the way through from beginning to end, I have to learn to leave the inspiration at the end of one workday and find it again the next. I always wonder if it will be there when I return. Sometimes it takes a little longer than I would like to find it, but I'm beginning to trust that it will meet me again, and it does. And then I will still be the one to decide when it's perfect—to bring it to a close.

Working on longer projects, such as writing a screenplay, making a film, sewing a large quilt or producing a series of works for a show may be a different kind of process than what you are used to. Also, sometimes larger projects will require you to collaborate with others. For someone who has become used to creating solely for herself and by herself, creating within collaboration can be an entirely new challenge. Your ideas of what is perfect may not match your collaborators'.

Whatever way we are used to creating, it's always good for us to challenge ourselves. Within our challenges, it's important to look for moments of perfection, and/or decide to let go of perfection entirely.

Visit www.createmixedmedia.com/creativethursday for more creative ideas.

29

Release the notion that creative time isn't valuable time.

Let's be honest in saying that society does not always value creativity. It seems like creativity is often viewed as something that is *fun*; and something that is *fun* should not be valued in the same way as something that *isn't fun*. (In the same way that something which comes easily to us shouldn't be as valued as something that is hard.) And I'm not just talking monetarily—although that is an issue as well. And why exactly are the arts becoming less valued and less present in our education system?

Each one of us has the power to change this perception. But it starts with us choosing to *value* our *own* creative time.

Career or no career as an artist, creativity is not only valuable, but also vital to our existence as human beings on this planet. Think about how often we employ creativity and thinking "outside of the box" in our everyday life. Having confidence in regard to your own creative contributions supports every other endeavor you pursue. I will go so far as to say that it makes you more secure with a strong sense of self-worth and self-confidence. If that isn't of *most* value in your life as a human being on this planet, then I don't know what is.

I've said it before, but I will say it again: We must be the ones to decide that using our creativity, in whatever capacity, becomes one of our *highest* priorities. You never need to justify time for you—least of all, creative time.

30 Visit www.createmixedmedia.com/creativethursday for more creative ideas.

Try out a daily commitment.

As an artist, you may have found that you are most fulfilled with your creative practice when you can complete a project in one span of time. My present style of creating has been developed out of the concept of daily painting. Initially, you might believe that creating and finishing a piece in one day is too much of a challenge (I did at first). I decided that I would paint a "daily" painting once a week. I would still try to finish it in a day, but I would only commit to creating one a week. You, too, might find almost instantly that this kind of creating is right up your alley; that in fact, finishing a painting in one day is more doable than you had realized. As it turned out, I'm actually pretty prolific, and I love working small.

One of the best parts of deciding to finish a piece within a day is that it really allows you to let go of some of your need for perfection. My thought was, "How perfect could it be if I only had one day to work on it?"

If you feel inspired, give it a try. Let go and paint and then paint some more until you become addicted to the satisfaction that comes from seeing a piece evolve from beginning to end in one creative session. My painting was perfect when I decided it was. And my willingness to share it with the world via my blog and my daily painting e-mail list was my accountability, not only to my audience, but to myself as well. I knew that I had to make the decision that a piece was finished— finished (and perfect) enough, that is—to share.

Balancing Too Much With Nothing at All

Now, if any or all of the other forms of resistance do not seem familiar to you, this one might. Do you love to do so much that when you have a small window of time, the thought of picking just one thing to work on overwhelms you, and you freeze and pick nothing?

Another false idea that we are taught is that we should limit ourselves to one artistic pursuit, one hobby, one creative discipline and truly master it. Someone (probably that same "someone" I mentioned before) decided that it is best to be an expert at just one thing in this life. Again, what I would like to ask is, why is

it necessary to be an expert? And if it is, then why not believe it's possible to become an expert at more than one thing in this lifetime? (See more talk about this in Chapter 9)

Although it is important to be able to focus, this does not mean that you have to limit yourself in what you choose to focus on. When faced with the resistance of too many possibilities, learn to pick just one.

Pick whatever inspires you the most in that second and, chances are, when you get started with one creative pursuit, it will instantly inspire all of your other disciplines. If a flood of new ideas comes to you and you are ever afraid of losing all of your ideas before you have time to execute them, write them down as they come. One good place to do this is in your sketchbook or journal.

If your inspiration has gone missing, this is where just choosing to make something can be the exact thing to reignite the creative spark. The list of ideas you made when your inspiration was overflowing comes in handy on those days when you don't think you have any ideas at all.

Remember the point behind all of this: to be creative. Just choose and get started! If your inspiration has seriously disappeared, don't worry, there's no need to panic. Just proceed to the next chapter; I promise you, we'll find it.

Visit www.createmixedmedia.com/creativethursday for more creative ideas.

CHAPTER THREE
Finding Inspiration

Since I've just spent the last chapter talking to you about all the ways you can put off being creative, I'm excited to share a little secret with you: You can actually use some of this very same time spent with resistance to seek out inspiration! On the flip side . . . ironically enough, finding inspiration can also be a form of resistance. Sometimes we resist getting down to business with our creating under the guise of "getting inspired" or waiting for inspiration to come. You will be the only one who knows the difference.

Have I mentioned that it's important to acknowledge sometimes that where you are is just where you are? All of us make progress in our evolution only when we are ready. If resisting creativity is where you are at, then that's where you are at. If you are in "getting inspired" mode, then that's where you're at. Embracing where you stand is not only comforting but it can be a powerful step to get you going in that new direction. You never want criticize or judge yourself for not being further along than you presently are.

I love getting inspired. In fact, now that I am running a full time business with my art, I long for the opportunity to take more time just for finding inspiration. As a business owner, continuing to feed your inspiration is one of the best gifts you can give yourself, not only for your own personal fulfillment but because a healthy connection to your inspiration also feeds your business. Sometimes being able to move through resistance quickly can actually keep you from taking enough time solely for the inspiration-gathering part of the creative process. Such a fine balance, this practice of creating is.

For the sake of this chapter let's just be where we are and allow ourselves a moment to let in some pure inspiration. So how do we meet with pure inspiration? You will need to know how to call upon this skill again and again throughout your creative journey. You have to begin by being open to it, whether deliberately or by accident, because inspiration is all around us. The question is, do you recognize it? Or does it seamlessly float away the same way it came in?

Visit www.createmixedmedia.com/creativethursday for more creative ideas.

Going in Search of Inspiration

Because it is all too easy to get caught up in our day-to-day lives, many of us find ourselves in a place where we feel more numb than engaged. We may not yet be in the habit of cultivating moments for inspiration. Much like taking time for creativity is undervalued, so is taking time for stillness.

So how do you start? You start with taking time for stillness and then you start with what you love. This applies to anything and everything that brings you the most joy. What are you doing when you lose all sense of time? It can be watching a movie, listening to music, enjoying a wonderful meal, sipping the best glass of wine, reading a good book, listening to a radio program or podcast, surfing your favorite blogs, flipping through a magazine, going to a museum or taking a walk. If you don't have a clue where to start, thinking of it this way can help: If you had all the time and money in the world, what would you do first? And if a nap is the first thing that comes to mind, do it! A nap is an excellent choice and probably means that you need some rest. Never underestimate the power of a nap to begin tapping into your inspiration. I often get entire painting ideas that appear right between my sleep and wake state.

Being well rested is key and the best state to be in when beginning your search for inspiration. Self-care plays a critical role in a happy life. I think many of us are depleted of rest as well as lacking quality nourishment and exercise. All of those things we're so busy trying to do? We can't do any of them without a healthy body—from which also comes a healthy mind. When a person's health is compromised, nothing else works. We are reminded of this when suddenly we get a cold or the flu and are stopped cold in our tracks. I like to consider creativity as a key element of that ritual of self-care, equally as important as rest, nourishment and exercise. But creativity does not happen to its fullest potential unless the other three are being attended to. Simply put, are you drinking enough water throughout your day? That's all I'm asking. And if you need a nap before you start thinking about any of the topics I've shared with you so far, please put this book down and get some rest.

Taking time for rest, stillness and creativity is not indulgent, it is a must.

Be on the lookout for spontaneous inspiration.

It's magical—that moment when inspiration floats in and you feel so energized that it's all you can do to keep from acting on your new idea right away. I like to call this "spontaneous inspiration," and it usually happens when you are in the flow of your life. You know, those days when you are having so much fun and everything just seems to be going your way? Many times you might be out of your usual routine; you might have the day off, or you might be traveling. I find that traveling is a perfect way for me to bump into spontaneous inspiration. Anything that takes me out of my usual routine, makes me more attuned to my surroundings. When you are experiencing this kind of living, everything can become a source of inspiration.

It's important to develop an acute awareness and receptivity to inspiration, and not become muted by certain kinds of daily routine. And I say certain kinds because some routines—taking a walk in nature or sitting outside in your garden, enjoying quiet time each morning through meditation or while sipping a cup of coffee or tea—support and encourage your continued connection with spontaneous inspiration.

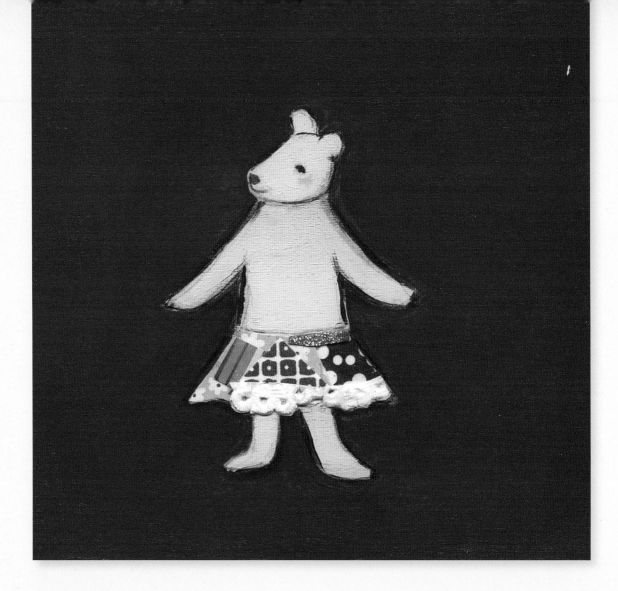

Find time for yoga and exercise.

Exercise does not always carry with it the best connotation for fun, so we don't always equate it to being another tool for finding inspiration, but it is clearly an aspect of self-care, therefore we cannot dismiss its contribution to our creativity. As much as I like my naps, I have also had some of the best painting ideas during yoga class—and not just during the restorative poses.

There are many different types of yoga and after trying several, I settled into the practice of Iyengar yoga. This precision-based yoga uses an intense mental focus on the physical aspects of each pose, to not only strengthen the body, but to calm the mind. Finding more ways to cultivate a happy mind allows your creativity to thrive.

So you would think it would be easy for me to incorporate more yoga into my life, right? Yes, but much like I shared with you about being exactly where you are, it takes time and practice to incorporate new ways of being into our daily lives. It takes commitment combined with patience—honoring the step-at-a-time that we do take.

Maybe you, too, have found a form of exercise that inspires you, or maybe you haven't noticed the inspiration yet, because your tired muscles are screaming at you. But have you have noticed the change in your mental state? You are on your way to being inspired. A lot of times we seek an activity that relaxes or even distracts our mind just enough to make room for some inspiration to sneak in. Exercise supports this effort.

Visit www.createmixedmedia.com/creativethursday for more creative ideas.

Try a change of scenery.

Change your location. Sometimes that's all you need to do to mix things up a little. And that can even mean moving around in your own home. Working from home, I find this necessary. That is why if you don't find me on the floor, you will find me with my laptop located in different parts of the house at various times throughout the day. I don't know what it is about sitting on the floor or the ground, but it seems to make me feel more in touch with my inspiration. Come to think of it, it is probably because sitting on the floor is slightly out of the ordinary from my usual routine of sitting at my desk or in a chair or on the sofa. Having a laptop certainly allows me to mix up my seating and those subtle changes in my workspace as well. Sometimes I even pick up my paints and move them to different rooms or outside.

Although routine is good—especially for keeping us grounded—it can also leave inspiration a little stale. Every time you break your routine just a little, the new shift in perspective can inspire many new ideas. For me, this is especially true when I actually leave my home.

I love my home and I love working from home, which means I also love staying home—sometimes for days at a time. This choice is intentional for a couple of reasons. One is that I work best on a project when I have uninterrupted focus, enough to gain some momentum which I use to carry me through the completion of the project. I also like to refer to this as a "mode." For instance if I am in creative mode, I like to stay in that mode as long as I can without switching to bookkeeper mode or packing-and-shipping-orders mode or running-errands mode. The other reason is that living in Los Angeles and relying upon a car to get around, maneuvering through traffic, struggling to find parking can take a lot of energy out of a person.

The downside to sequestering oneself at home for extended periods is that it can result in what we often refer to as "cabin fever." You might love being at home so much that you honestly don't even recognize cabin fever is happening. Suddenly your focus becomes less sharp, and it can feel like you're frittering away time. This is right about the time when crankiness begins to set in. And the desire to stay home and get yet one more thing done will completely override the need for a break. That's the exact time to remember: Breaks and naps are good for you! They are vital. A break from work, a break from routine, a break from location can be just the thing to give you a new perspective.

Draw or write in a sketchbook or journal.

Author Julia Cameron is known for encouraging artists to practice a daily habit of "morning pages" to keep the flow of creativity going, and I would encourage that same practice with a sketchbook. I think we often feel that we must have an idea to start drawing, but many times sitting down with my sketchbook and allowing the pencil to move freely across the page is exactly where my new idea is born. The key words here are "move freely." In order to summon ideas this way, the usual suspects—judgment or self-criticism— must be kept at bay. Rather than feeling intimidated (again) by that blank page, in a sketchbook or journal, it must become an invitation to play—a place to meet up with new inspiration.

I've found that drawing regularly keeps a steady flow of ideas coming. New characters almost always appear first in the pages of my sketchbook. This is when I have to be especially careful to hold back judgment of *anything* that shows up on the pages of a sketchbook. In fact, sometimes I won't even recognize that I like a character right away. Because it's brand-new, it might take some time before it grows on me. I realize this when I flip back through the book sometime later and say, "Hey, look at that little fellow. I'd like to incorporate him into this painting." Other times I do have an idea of a new character, and I work him out through loose renderings before I paint.

If you don't know where to start in a sketchbook, just start moving your pencil or pen around the page, just like you would start a doodle. It might start with one line or the repeating of one shape over and over. If I'm feeling at a loss about where to start when that pencil hits the paper, I start with a circle. I might even go over it and over it again until I feel ready to move

of a classroom setting, it took me quite a while before I felt ready to be a student again. Yet being a student is one of the best ways to spark inspiration. It wasn't until I started teaching that I realized just how much I had missed being a student.

For artists looking to expand their creative toolbox,

the pencil in a new direction.

It can be challenging to create without judgment or expectation in the way we did when we were kids, but when doing initial concepting, it's one of the most important times to foster a safe and supportive environment. Sketchbook work or journaling is a delicate time when inspiration is being fed, and new ideas are being born.

Learn something new.

I remember how excited I was to finally be out of school. And, because I had been so excited to be out

it's essential to find the right kind of class. By "right kind of class" I mean one that is led by a teacher who creates a safe environment that encourages our creative selves versus a teacher who wants to criticize. I have had several moments in my artistic life where I have been shut down, and had I taken those moments to heart, I would have stopped creating forever.

As I mentioned before, art and creativity are completely subjective, and while technique and certain kinds of aesthetic can be taught, a good teacher will know how to teach these skills while also supporting pure creativity.

While creative classes are perfect for furthering our skill set, they are not the only kind of class that will spark inspiration. In fact, I think taking a class in something entirely new stretches us past our comfort zone, giving us that shift in perspective again. One of two things can happen when you take a class; you might come out of it not liking what you learned, or you might love it so much that it is life-changing in the most powerful way. Both possibilities will teach you more about who you are—what you do or don't like. Gaining that understanding about yourself is essential to finding your true creative voice.

Thanks to the Internet, there are now countless opportunities to learn from people all over the world who can inspire and/or challenge us. There's almost no excuse not to venture out and take a new class. You don't even have to leave the comfort of your home to learn. Exposing yourself to something entirely new will not only increase your skill level and build your knowledge base, but it might open you up to a possibility that you had no idea you would love so much.

44

Explore other examples of creativity.

Certainly a trip to a museum to see an exhibition is on the agenda as an artist. Traffic and limited parking aside, one of the benefits of living in or visiting a city such as Los Angeles is that it offers so many kinds of exhibitions. There's nothing more inspiring than experiencing great art up close and in person.

I know that living in a visually saturated world, artists can also be hesitant to see too much work from others for fear that it may over-influence their own expression. But no matter how much art is being created and shared—especially online—seeing what others create can be enriching. Our job as artists is to see what we like in the world and be able to translate it and express it in such a way that it becomes uniquely ours. This is especially true of those of us who work professionally. While mimicry of artists who inspire us is often how we start out creating, moving away from that is exactly how we learn to develop our own style.

Use the influence of work you admire as a jumping-off point to your own expression. While we don't want this influence to supercede our own creative ideas, we also don't want to stop appreciating others' work simply because we are too fearful of all looking the same. One of my early mentors said, "There are no new ideas. What makes something new is our take on it."

Keep in a constant flow.

The beauty of inspiration is that once you know how to summon it, it will always come again. Even on the days when it feels

like inspiration might have gone missing, it is never far. Now that I'm practiced at being in the flow of new ideas, it is becoming my way of living, and it's almost like I can't shut it off—not that I want to. But now I get so many ideas that I can hardly keep up with them all. That is why keeping a pen and paper and/or your smartphone nearby is perfect for catching inspiration, so you can return to it when you are ready.

Appreciate where you are and what you already have. There is no better way to stay in the flow than a state of gratitude, and there's nothing that shuts down inspired ideas more than intense dissatisfaction with where you are. Since we never get it all done, we are always on our way somewhere. While looking forward to what's ahead is exciting, there is also always so much to appreciate right where we are. A daily gratitude list works wonders for getting you happy *right now*.

Finding It in Your Favorites

Inspiration is easy to find in the things we're passionate about; yet sometimes we actually lose sight of this.

In case some of my favorite things also happen to be yours, I want to share with you some places I find inspiration.

Take a picture.

Thank you, iPhone, because now whenever you are with me, I can snap a photo of what inspires me. You may not consider yourself a photographer, but using a camera regularly to capture and collect imagery that moves you is also a way to train your eye to discover your aesthetic. Sharing your photos on a blog or online photo gallery is a great way to catalog your imagery and provide others with some inspiration as well.

Visit www.createmixedmedia.com/creativethursday for more creative ideas.

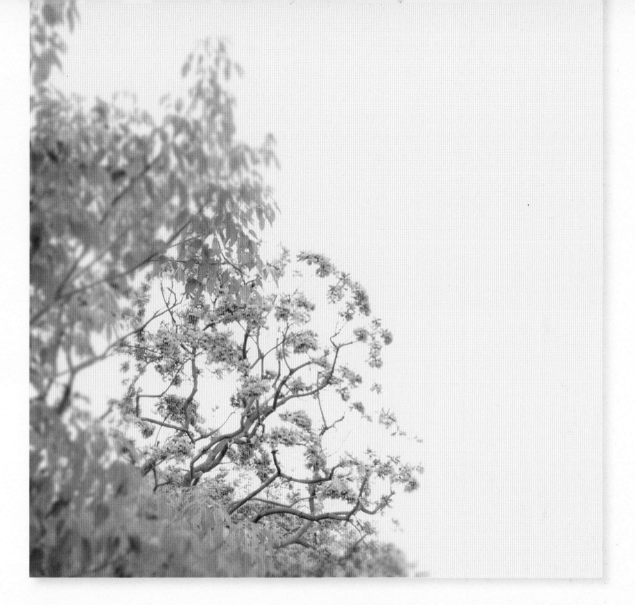

Go back to nature.

I'm writing to you from the garden right now. I was feeling stuck in my writing, and it is one of those beyond-gorgeous early fall days in Southern California, so I stepped outside and sat in the sun—on the driveway in our backyard, to be exact. (There's that sitting on the ground again.) There is something powerful that happens when you stand on the earth with your bare feet in the grass or the sand. No matter where you live, every place is blessed with its own beauty. Nature is so pure, calm and consistent in its being. Connecting with nature can instantly ground you—observing a butterfly, listening to the birds sing or the leaves rustle, feeling a soft breeze on your skin or watching the ocean waves move in and out. Oh,

and to stare at a flower. I can stare at flowers forever, endlessly fed by their color and the intricate, delicate details of each petal. For this reason I always love to keep fresh flowers in the house. Think about what nature means to you and in what environment you feel the most at home. Then take some time regularly to recharge this connection.

Go to the store, and then make a meal.

There's something about going to the grocery store or an outdoor market to choose fresh produce that makes me feel so grounded. I'm sure it has something to do with the fact that I'm caring for myself and whomever I'm preparing the meal for. Cooking and baking are also so cathartic and relaxing to me.

Look at things printed on paper.

Are you like me? Do you love to flip through books and magazines—preferably sitting in the middle of a big pile of them spread out on—you guessed it—the floor?

What I love about magazines in particular is that you can tear pages out and save them in files. Usually when I am seated in the middle of a pile of papers on the floor, I will have tear sheets organized by subject matter sprawled around me. I learned about tear sheets when I worked as an assistant to an interior designer who taught me that tearing pages out of magazines and noting what you are responding to is exactly how you begin to train your eye to recognize your particular design aesthetic. So if you are really stuck on knowing what inspires you, this may be a good way to start. Begin pulling pages from magazines and making notes on the pages. Is it the color you are drawn to? The design? The object itself? The feeling the imagery conveys? I have a file just for a particular feeling that I respond to.

I also treasure all kinds of cards, from holiday cards to postcards, and I keep a couple of boxes of my favorite ones that I have collected through the years. Collecting imagery is how you begin to make a vision board where you take images and collage or paste them onto one board, either creating a piece of art or using it as a collection of imagery to help remind and focus you on a particular goal. When you see a series of images together, not only will you gain insight about what your aesthetic and style are but about what is calling to you in your life.

So building a collection of printed material is not only a good way to develop your creative voice, but it also serves as a perfect place for your cat to take a nap. Every time I spread papers on the floor, Garbo has to sit on them. I think she hopes to get in on the inspiration through osmosis.

48

Spend time with those you love.

I mentioned briefly that socializing is a key element to my inspiration. One conversation, even by phone with someone I adore, can energize me for days.

Creatives need inward time to create, but much like it's important to venture outside once in a while, it is important to strike that balance of introverted time and extroverted time that includes quality interaction with those whom you love.

Sometimes I create distance around myself to focus on my work. I've found that at times this is the only way I can really gain momentum on a project. However, I notice right away when I have created too much space, in the same way I notice when too much socializing is depleting my energy. In both scenarios I lose my grounding. I feel off balance, not like myself.

When I have not been around people enough, I begin to slump into a mild depressed state, like a muted version of myself. The minute I come into contact with someone who inspires me, and we have one of those conversations that could go on for hours, I light up, I recharge; I remember who I am, what I am doing and why I am doing it. It's like an instant burst of connection. This is probably also due to the fact that I am equally as passionate about understanding life and having real, genuine, truthful conversations about it. Engaging in a good discussion is definitely another inspiration kick-starter for me.

Human beings are comforted when they feel seen, heard and understood. We need friends who support us in the greater vision of who we are and want to become. We need friends to lean on and to talk

things out with, and in return we need to be a listener to them on the days when they need someone. I have found this reciprocity of the human connection to be vital, especially for creatives.

Nurture your bond with a pet.

Speaking of those you love, there's nothing that reminds me to enjoy my life more than spending some time with my cat, Garbo. Animals are an important part in many of our lives and they've clearly had a great influence on my work.

Spending time with animals can remind us to take things in stride; to savor simple moments; to love unconditionally.

Turn on some music or watch a favorite film or show.

Because I create almost solely from a place of joy, it's important for me to always do what I can to stay tapped into that stream of joy. (I'm listening to Christmas music as I'm writing today—not only because as I'm writing this, the holidays are upon us, but because Christmas music makes me happy.)

Chances are that you have several styles of music you like that can put you in the creative zone. Over the years, I have compiled several playlists dedicated to painting. I am especially fond of soundtracks.

Speaking of soundtracks, I also love films. Sometimes watching a good film or an episode of my favorite TV show can inspire me for days. The writing, acting, lighting, cinematography and music all coming together to create one piece of art. There's nothing better. (Dancing to said music is also very inspiring.)

Take a walk.

Never underestimate the power of a good walk. When I am feeling off-balance even a short walk to the grocery store can make me feel instantly better. The physical movement, the change of scenery, the contact with nature—all of these things combined can be just what you need when you are feeling stumped, frustrated, fearful or uninspired.

Read a book.

If you are like me, maybe you read several books at once. Try randomly opening a book to any page and trust that what you read might be just what you need to be reminded of in that moment.

Or, read a book cover to cover. Books are a great source of inspiration. Sometimes even seeing the beautiful cover of a book as it sits on the shelf can inspire you.

Visit www.createmixedmedia.com/creativethursday for more creative ideas.

Organization and Decluttering

Does excess clutter sometimes leave you truly depleted and at a total loss of where to begin? Start with organizing a small area of your home or office. It can even be just one drawer. Then, the next day, move on from the drawer to a closet and the day after that, an entire room. You will be surprised at how easy and invigorating it is to continue once you get some momentum going.

Feeling organized, empowered and lighter from the "things" that are no longer serving you, will you give you an instant energy boost. Two of my favorite books on this topic are *Living the Simple Life* by Elaine St. James and *Clear your Clutter with Feng Shui* by Karen Kingston.

Do nothing.

In my efforts to share all the actions you can take to be inspired, I almost forgot to include one of the most important ones: Do nothing. Inspiration needs room to breathe and sometimes in the passionate pursuit of it, we strangle it or we miss it entirely. Sometimes the best ideas come when I step away from it all. After effort upon effort to come up with an idea, I will often stop trying, and that's exactly when it just breezes in.

Learning how to tap into this kind of inspiration without having to hit the wall in order to relax into it is ideal. Give yourself permission to do nothing. This is where you can find some of your richest insight; but of course you aren't trying to find it, because instead, it just finds you.

Treat yourself.

And if all else fails While I'm not an advocate for mindless consumerism or consumption, sometimes indulging in a favorite food, taking a little shopping trip, going to lunch with friends or enjoying Cracker Jacks and ice cream with a movie might be just what you need to break out of your rut.

CHAPTER FOUR

Commitment

Thirty days! That's the amount of time it takes to adopt a new habit. And this means thirty *consecutive* days. I believe this to be true because this is about how long it took me after numerous thirty-consecutive-day attempts to make the simple act of flossing part of my daily routine. Flossing is very good for you, by the way. And once it becomes a habit, you can no longer go without it. Practicing creativity is the same. Once it becomes a habit, you will no longer be able to go without it. Don't you love that?

The way I've heard it explained by scientists is that our brains are made up of neurons that fire over and over again on the same pathways—also known as our habits of thought. In order for our brains to learn and adopt a new way of being, the neuron has to essentially regrow itself in a new direction. It takes a little time for a new neuron to be formed in our brains. (I'm guessing approximately thirty days.)

When I learned that there is scientific reasoning behind why it sometimes takes so long to adopt a new habit, I felt relieved. Honestly, sometimes my greatest frustration is that new beliefs and ways of being do not take effect instantly. Wouldn't it be wonderful if you had an enlightened moment, were ready to make a change and, presto, you could do it easily from that day forward? Instead, it takes consistent, conscious effort, but it's worth it.

The Habit-Forming Transition Period

Visit www.createmixedmedia.com/creativethursday for more creative ideas.

You might discover that it takes you several thirty-consecutive-day attempts to reach the real level of commitment you need to form your desired habit, so give yourself some breathing room on this. It takes time and dedication to develop the habit of making you and your creativity a priority.

A common example for this kind of commitment is when we try to incorporate exercise or more nutritious meals into our everyday lives. Commitment seems to be a necessity in living and maintaining a healthful life-style, so as I write this I am wondering why this idea of genuine self-care is such a challenge for human beings today.

What are habits anyway? We seem to frequently associate the word "habit" with *bad* rather than *good*, but when I looked up the definition, this is how it read:

An acquired behavior pattern regularly followed until it has become almost involuntary.

That's it, right there—exactly what we are after when it comes to our creativity! We want to develop an involuntary pattern of creativity in our lives. This takes a firm commitment, not only to your creativity, but a commitment to *you* and your well-being. The question is, are you ready to commit to you?

As I lead you into this topic of commitment, I want to repeat that it *takes time*. I don't want you to read this chapter, put the book down and start creating, only to find that you weren't able to achieve that same level of commitment the next day.

Of course some of the issue goes back to the previous chapter on resistance, meaning that doing exercise comes with its share of challenge and physical discomfort to your body, and adding more nutritious meals to your daily life can also equate to dieting, or removing some foods from your routine that you currently enjoy. Although I hesitate to equate accessing your creativity every day with these other kinds of changes, committing to creating can bring with it those same challenges—less physical discomfort, but perhaps more emotional discomfort.

Any kind of change from routine brings about some discomfort. A commitment to any of these examples is intended to create change in our habit of being. What we need to not lose sight of here is the payoff. There *is* a payoff, and, when it comes to fulfilling creativity, it is BIG. The only reason we choose to incorporate any kind of intentional change is if we believe it will make us feel better, happier, more content in our day-to-day

lives, yes? Is this true for you? Are you, like me, on a continual quest to keep expanding into the fullness of your best life? If so, then keep reading.

We know that it takes time, so when and how do we start with this new commitment we are making to ourselves? Anytime we are ready. How about right now? The fact that you are reading this book means that you are ready to take the next steps in your creativity. Whether you are just beginning on this journey or whether you are already well-immersed in a practice of regular creativity, a renewed commitment is a continual part of the process. Your commitment might be to simply start being creative, or it might be to learn an entirely new creative practice working within a new medium, or it might be to complete a series of work for a show or to begin a brand-new project. Whatever it is, it takes a decision to start and see it through to the end.

Visit www.createmixedmedia.com/creativethursday for more creative ideas.

Setting Accountability

Report regularly.

Keeping a blog is a perfect way to catalog your own progress. Like a journal, you can keep adding to it and keep track of progress made in any kind of endeavor. Progress you can actually archive and see is very rewarding. In fact, tracking your progress may be the key to encouraging you to keep taking your commitment further.

A blog is also a nice place to build community, while allowing some distance. Although you are accountable to your readers, you do not have to stand before them in person every day at the same time. You post to a blog when you feel inspired, and your readers visit your blog when they feel inspired. There is no pressure of social interaction, yet the opportunity for socialization exists. You decide how far to take it.

In fact, speaking of blogs, I think the fact that we now have access to so many people and their beautiful creative endeavors allows us to be more inspired than ever to tap into that for ourselves. We see what is possible, we become inspired and we believe that we can do the same. I credit blogs with a huge resurgence in the vitality of creativity and the arts today.

CREATIVE
THURSdAY
daily paintings

& a podcast

by Maiea

I also think that blogging can be the perfect vehicle to kick-start a person's creativity, primarily due to the accountability factor. Commitment, for me, really took hold when I publicly announced to my blog readers and those who signed up for my daily painting e-mail list that I would be painting and posting a new original at least five days a week. I put it out there publicly, which meant I had to follow through. Now if accountability is not highly important to you, you might try a different tactic. The most important part of this process is knowing yourself, understanding exactly what motivates you and honoring that.

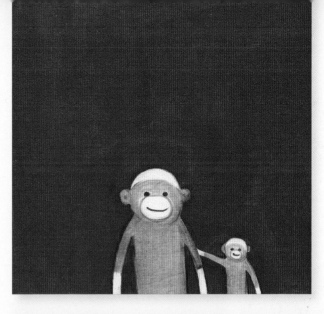

Whether you have one reader or thousands, if you post to a blog publicly, or perhaps on some form of social media, somebody, somewhere will find you and see what you have shared. Readers become especially interested when they see you make a public statement about a new intention, commitment or project you want to complete. Why? Because they want to follow along. Why? Because most likely they are going through the same kinds of resistance we all go through, and it inspires them to move through their own resistance when they see someone else doing it.

In fact, some find it is easier to stick to a commitment within a group setting, even if it is a group of two, such as my friend and I had with our Creative Thursdays. Much like setting an intention, deciding to make a commitment achieves the same result. Even if you haven't followed through on your commitment yet, just deciding to commit creates a huge shift in where you are headed. And if you make that decision with others, there is power in numbers.

I hope you find it comforting to know that what I'm suggesting here isn't something that has to be done alone. Yes, you are the only one who can go from point A to point B, but that doesn't mean that you can't go from A to B alongside someone else going from point A to point B. It can certainly be more fun, as long as you don't get sidetracked comparing your progress to theirs. (We will explore the idea of comparison in Chapter 8.)

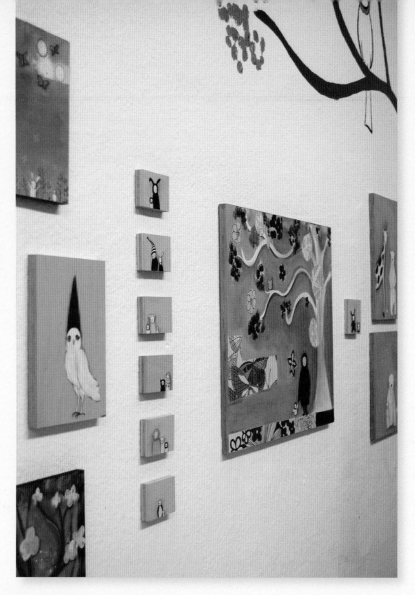

Establish deadlines.

Despite the adrenaline and stress that come with preparing for a deadline, for many of us it is exactly what works. A deadline gets us going; it practically forces us to make that commitment to start and finish something. It is also another opportunity to hold ourselves accountable. We might be willing to let ourselves down, but we are much less willing to let someone else down.

When a paper was due in college—the source of one too many all-nighters for me—I made the time to get it done. I would rather go through the resistance and fear around writing the paper than live with the disappointment and shame that would come from not following through, or worse, getting an F as my grade.

Although many artists—myself included—use deadlines frequently as the fire-starter to their creativity, they can also be a major cause of burnout. Experiencing this kind of adrenaline rush, plus the accompanying stress, gets old after a while. So I want to offer you the encouragement that will build a strong foundation and sustain a long and inspired creative life, but if you need a push to get you started, then by all means, choose a deadline and get going!

It's important to note that a deadline alone does not bring about that kind of crazy stress; it's how we choose to work within that deadline that creates the stress. A little writing every day creates a book. A little painting every day creates a body of work for a portfolio or a show. Tackling little bits of a project daily can be a lot easier than tackling an entire project all at once.

Visit www.createmixedmedia.com/creativethursday for more creative ideas.

Practice consistency.

Another way to get started is by choosing the same time each day or maybe just once a week (such as my Creative Thursday) to pursue your new practice. Block off that time. (Go block it off in your calendar. Right now!)

How does our work get done every day? Usually we have consistent work hours, maybe we go to an office or a classroom, and we get our work done within that time frame. Even if we don't have a lot of energy that day, we show up, we try, we accomplish something. This kind of commitment that we give to our boss, our teachers, our friends and our families is the kind of consistent commitment that we need to give

ourselves. You need to show up, even if you just sit there waiting for inspiration, or you barely write a word, or draw a line on your page. If all you do is have a cup of tea and think about what you want to make, you've followed through on your commitment and remained consistent.

If repeatedly starting with a clean slate in a set amount of time is too daunting, then start practicing consistent creativity with something similar to what you already do, like picking out an outfit for the day or cooking or gardening or even housework, for instance. Creativity can be inserted into everything we do, and the more consistent we are, the easier it becomes.

So if you consistently prepare a meal, you might want to begin trying new recipes. If you don't cook, you still have to eat, so maybe your commitment to creativity begins with choosing a new restaurant to visit once a week. Maybe you just want to take a new route to the restaurant or the grocery store.

If you are cleaning your house, maybe you want to start in a different room. Maybe you want to try a new cleaning product. Even daily routines can be more fun with a little creativity mixed in regularly.

Commitment to creativity doesn't have to be a grand gesture; it can be small. Any choice to try something different, to step outside of what is familiar, makes a difference. When you consistently make the decision to try new things—to expand your creativity— you open yourself up to be receptive for the next new idea to come in. What keeps us stuck is being unwilling to take even the tiniest step forward. In the same way that creating a little at a time adds up to a finished piece, one tiny step always leads to the next step and the next step and the next. We don't have to see all of those steps out ahead of us when we take the very first one. All we have to do is be ready to take the next one.

Visit www.createmixedmedia.com/creativethursday for more creative ideas.

Start small.

One thing that helped me commit to the practice of daily painting was to work small. Nobody expects a large masterpiece to be created in a day—a small painting will do. And when I say small, I also mean tiny. Sometimes the panel size I work on is 3" x 2" (8cm x 5cm) or 3" x 3" (8cm x 8cm).

I often end up painting several of that size in a day, but if one is all I am able to complete, I still get that sense of satisfaction that comes with starting and finishing a work in a day. Working in this size allows you to scan a painting easily so you can post them online with minimal effort. It's far less daunting to get started on a small canvas than a large one. For works I want to complete in a day, I often choose a 6" x 6" (15cm x 15cm) size and no larger than a 9" x 12" (23cm x 30cm) size. Satisfaction often comes from completion, so when developing your own creative practice, set yourself up with projects that can be completed in a short amount of time. Make it easy to follow through on your commitment. Even if you aren't able to finish it, at least make it easy to feel progress.

Creating on such a consistent basis may feel forced and awkward to begin with when it's not yet familiar. Hold fast and work through the awkwardness and soon what was unfamiliar will become the new normal.

CHAPTER FIVE

Setting a Time Limit

Many of us don't commit to our creativity because we think we don't have the time. Or we think we need some open-ended, wide expanse of time. While a substantial amount of time certainly is a nice way to practice, this is not necessary or realistic for most people's lives. I certainly encourage aiming to set aside nice chunks of time for yourself, but maybe you are working full-time, or raising a family full-time or, as is the case for most of us these days, doing both. I understand that this feels like it leaves little time for you to fulfill your daily routine, let alone find time to be creative.

But this is where I want you to take a moment, flip this notion around and realize that a time limit actually works in your favor. Because most of us—even those of us with our own creative business—don't have time to aimlessly be creative for days on end. We all have to learn to work within a certain time frame. This goes back to the idea of working toward a deadline. A self-imposed time limit has a similar effect to a deadline, minus the extra pressure.

This feeling of not having enough time has to go. It's just another form of resistance, an excuse. It seems to be the very excuse many of us use to keep from doing all of the things we really want to do. It's amazing what we can accomplish when we just commit to fitting what it is we *really want to do* into our day.

My yoga teacher says even doing one pose a day is so much more beneficial than coming to class just once a week. One pose a day. That sounds doable, right? And of course what happens is that the one pose might lead to the next and the next. There can be a similar outcome with the practice of daily creating. Even if you don't feel like it, just start, just do, just create *anything,* and it might lead to the next something.
And if not, at least you tried; that's what counts.

Let's say that you have committed to set aside some time each day—or maybe every other day or maybe just once a week—to start. I would say once a month if that's all you can do. However, momentum is what we are after here, and working on something once a month takes a lot of extra effort to gain that momentum and then leaves plenty of time to fall out of the momentum between those monthly dates.

Now I want to suggest that in your committed time frame, you also set aside a time limit on what you want to accomplish. For example, if you are in the idea stage, see if you can decide to come up with one or several ideas in a certain time frame. If you already have your idea, see if you can start and finish it in your set-aside time. Yes, you read right, start and *finish* it. If your project is much larger than can be completed in a day, let these initial creative bursts be studies for your larger piece, or set a time limit on completing a certain portion of your larger piece.

Visit www.createmixedmedia.com/creativethursday for more creative ideas.

The concept of daily painting might lead you to think that an original painting takes an entire day to complete. I haven't actually taken a poll of this with all the "daily painters" out there, but from my experience, a "daily painting" takes anywhere from one to three hours. The length of time it takes me to complete a piece depends on the size, the amount of detail and how "in the flow of my inspiration" I am on any particular day. One of the reasons my paintings have so much negative space (which has become part of my signature style) is that it makes it easier to finish one within a day. Finishing a painting in a day does not allow time for too much obsession over a ton of details. The other reason I incorporate negative space in my work is because I crave space and breathing room in my life. If I can't find enough of that space around me in the city, I can at least create it in my home environment and in my paintings.

So if you decide to commit to a daily practice, be open to letting something new be born out of your present working style. When I first started daily painting, I had no idea that I was on the verge of developing an entirely new style that would also be the very door to supporting myself with my art. Before I started daily painting, my work was larger and usually much more involved. Although when I think back to that day of painting on the blue tarp on my bed, I felt so satisfied because I completed several small paintings that day. Through my practice of daily painting, I've learned how working frequently and fast suits me.

Visit www.createmixedmedia.com/creativethursday for more creative ideas.

Working creative practice into specific time restraints teaches us about ourselves. You may find that this is not your style at all, that you dislike trying to start and finish a piece in one block of time. Maybe your gift is in rendering the finest details that truly take time and great care to finish. The reason daily painting is so fulfilling for me is that patience has never been my virtue, and I realize that I have always loved the satisfaction that comes from starting and finishing a project in the same sitting. I also learned that I can be very prolific and that getting those ideas out, and out quickly, serves my overall creative process, not to mention my mental well-being.

Now if I don't create frequently, I get cranky. I honestly don't know how I made it all those years without creating the way I do now. It's the same for me with my yoga practice. If I don't do yoga frequently, I also get cranky. I think it's safe to assume that we are all after a little more joy and a little less cranky in our lives, yes? I believe that everyone needs to make it a priority to find those activities that bring them the most genuine joy. Every time I sit down to paint, I am so thankful to have found this.

We've established that working creativity into regularly scheduled slots does not have to take an entire day, so consider what you can fit into one hour or two hours or three hours. Personally I find that three hours of straight creativity is ideal. After that amount of any type of creating—sewing, painting, writing, sculpting—I am done; I have fulfilled my "hands-on" creative quota. New ideas might be coming to me at various times, but rendering them is only a small portion of any given day. You see? You don't even need a whole day set aside (although those are especially nice). When we take entire days to create—like at a retreat, for instance—even then the classes are split into three-hour increments with breaks in between. Choose a time, set a limit, take breaks when you need them and let the creating begin.

Visit www.createmixedmedia.com/creativethursday for more creative ideas.

Redefining the Role of Perfection

Oh, this is a tough one for all of us. Over time I've realized that all aspects of life flow more easily when we do one thing: Love ourselves. When you accept (and love) who you are, it gives you confidence in all you do and also encourages more kindness and compassion toward others. This idea of loving yourself is at the core of the creative person, especially the one who is willing to confidently share her work with others. The Beatles are so right: "All you need is love."

I understand that there are artists whose art is born from personal trauma and turmoil and that their creative process is therapy that hopefully helps them heal. My guess is that even with this type of creating, their process is ultimately in service of becoming a person who loves himself.

Personally, I paint from joy. Writing is a little different, in that the process of expressing myself through words helps me work out my thoughts and find clarity. However, even when I write, I must still be working from a healthy mind-set. You might discover that when you embody that space of peace, truth and acceptance of who you are, you have the most fun creating and maybe even create some of your best work.

Increase the Self-Love, Decrease the Self-Judgment

Part of developing a love of one's self is to work on releasing self-judgment. As adults, self-judgment (not to be confused with *self-critique,* which results constructively from a desire to become better at one's craft) is one of the first hurdles we must get over to begin creating at all. We aren't born with self-judgment; it is a learned behavior, and it gains intensity over time with questions such as: *Am I even creative?* • *Am I talented?* • *Am I good enough?* • *What will somebody think of my work?* • *Will they like my work?* • *Will they like me?* • *What if they don't like me or my work?* • *What if I don't like my work?*

Visit www.createmixedmedia.com/creativethursday for more creative ideas.

When I write about embodying a space of peace and acceptance with who I am, these are but flash moments in time. I wish it were continuous, but I am a human with insecurities from the past and new ones that crop up every time I release a little part of my art and my soul out into the world. But I'm aware of my insecurities and I do my best to soothe them and create anyway. The days with peace and acceptance come more frequently now, and I credit my regular creative practice with being a great influence in this direction of more love for myself. It's hard not to love yourself when you are listening to your intuition and following through on the direction your life is calling you, especially creatively. I've never had more moments of consistent, pure happiness than since I fully stepped into my life as a creative. This is why I am so passion-ate about sharing this with you (and any person within earshot who is inspired to listen).

I believe in self-acceptance, so much so that I think the more of us who become all we are meant to be—find work that makes our hearts sing and grow in our love of ourselves—the more we might actually come close to some form of world peace. We are far less likely to pick a fight, find fault with another or step into any conflict when we are content within ourselves.

Self-judgment is the cause of so much internal stress and insecurity among people. And that internal stress spills out as anger, frustration, resentment, agitation and all-around crankiness into the world—especially to those closest and dearest to you. If you aren't swayed to make creativity a regular practice for *your* benefit, then do it for the benefit of others.

Striving for the Proper Perfection

Let's talk about perfection for a moment. Most of the creatives I know suffer from being a perfectionist with their own work at least a little bit . . . maybe a lot. However, they do not let the desire for perfection keep them from creating or sharing it with others.

It is important to recognize perfection for what it is. Perfection is a standard that we set, especially when it comes to our art. Because art is subjective, it is not like a sport at the Olympics where standards of perfection must be carefully measured in a competition.

I think perfection gets a bad rap sometimes, so I don't want to come down too hard on it. I define perfection in this context: *A desire to create with excellence.* That is, to me, *proper* perfection and not something meant to flare up self-judgment or discourage us from even trying something in the first place.

I believe that a desire to create excellent work is healthy. I like to approach everything I do with excellence. I have heard several times from those who have achieved phenomenal success that no matter what job we have, from being a sanitation worker to a CEO, we should bring excellence to every task we do. It's about choosing to show up in your life as your best, no matter where you are, what you are doing or who you are interacting with. When you show up with an intent for excellence in all that you do, it feels so good that you can't help but feel good about yourself. Of course we all have off days where it's hard to get out of bed, let alone feel anywhere remotely close to excellent. On those days, excellence still exists—it just takes the form of being kind and gentle to yourself.

Visit www.createmixedmedia.com/creativethursday for more creative ideas.

One actual definition of perfection reads, *When something is free from all faults and defects.* Because we are human beings, and nowhere near free from faults and defects, let's just strike that definition when it comes to our creating, shall we? I have decided that perfection is in the eye of the beholder, so as I suggested before, why don't we become the deciders of when something is perfect?

Many times in my painting, "mistakes" happen. I have a moment of panic, and then I remember how often that very mistake becomes a perfect part of the painting—sometimes the very thing that makes the painting especially wonderful. Creating is an organic process, and we need to allow it to unfold into what it is meant to become. Perfection already exists in what is. It is up to us to recognize it.

For example, in these painted images of the rabbit and the cat, I painted the rabbit first. I was struggling that day with my painting style and couldn't get the face of the rabbit the way I liked it, so I kept wiping away the paint with a damp cotton swab until I accidentally revealed a face I just fell in love with. I loved it so much that I created a similar face in the cat in the next painting. I not only had two paintings I adored, but I also stumbled upon a new technique, all because of a "mistake." Now I'm never afraid of washing away a face with a damp cloth because sometimes what is revealed is the exact sentiment, expression and look I was hoping to find. Because of this experience, I always remember to let a character in a painting become who it wants to become. I guide and I create them, but ultimately *they* shows *me* who they are.

Pursuit of perfection becomes an issue when it is wrapped up with self-judgment. Instead of encouraging us to create with excellence, perfection paralyzes us. We then either refuse to share the work we have created with others, or we stop creating entirely. We feel that if it is not perfect (by our standards or someone else's), it is not good enough. The pressure alone in this kind of scenario is enough to shut down our inspiration entirely. We end up creating for someone else, for a desired outcome, and not creating for the sake of creating.

We need to have days where we create only for the sake of creativity—no desired outcome, just for fun. It doesn't mean we can't approach this process with excellence. However, during this time, showing up with excellence will mean removing *all* judgment. These are days when we make a decision to invite inspired creativity in, by looking solely for the beauty and already existing perfection in ourselves and in everything we make.

As with all of the suggestions I've made in this book, these kinds of changes take practice. I don't think we are conditioned to wake up looking for what's beautiful or right about ourselves, our choices and our creations, let alone others and their choices and creations. In fact, some days it feels like we live in a heavily critical and judgmental society.

To make the decision to go against mass consciousness always takes a little extra effort. But that is also when positive change can happen. At the very least, it's worth starting with more unconditional love for ourselves.

Visit www.createmixedmedia.com/creativethursday for more creative ideas.

We must also always be willing to evolve, to be new at something again. A desire to continuously refine your skill level or challenge yourself creatively is a healthy approach. This also lets us off the hook when it comes to perfection because it means we can't reach that state of perfection all the time, especially when we are learning something new.

Practice makes perfect. That is what we are always told. In this case, it's true, although I'd change "makes perfect" to "helps you adopt new, healthier ways of being in this world." It doesn't quite have the same ring to it, but you get the idea. When we decide to take a loving approach to our perception of ourselves and our creations, life gets better.

Finding Your Voice

It's right about now, with all of this encouragement to increase self-awareness, that I'm realizing my book is bordering on becoming more than just a book on creativity, because here's the thing: The practice of creativity and knowing who you are go together. You just can't express one without the other. The best and quickest way to find your creative voice is to practice daily creating. The more you create, the closer you will get to discovering or even stumbling into your unique point of view. It can't help but reveal itself to you through your process. This approach is also known as "working quick and fast to get you out of your head," so that self-judgment barely has a chance to make an appearance.

If you are uncertain about who you really are, the practice of daily creating will not only help you find your creative style, but it will help you find *your* voice. And if you already think you know who you are, you will only come to know yourself better.

There are moments when I question something I've made, but thankfully it only lasts for seconds, like some residual self-doubt desperately trying to hang on from the past. I try not to take those moments of doubt too seriously. Try to see these moments of your own doubt as reminders that you care deeply about your work, that you are always striving to evolve, become better and create something you are extremely proud of. That sense of pride can ultimately override any residual doubt, and the love you have for your creations will return.

That surge of love you feel for your work—that is when *you know* you've created something good. (Note the emphasis on the words "you know.") One more time: Art is subjective. Someone else might think that what you have created is not good, but if you are happy with it, that is what matters most in your creative process. How have I come to this conclusion? I have had several people along the way discourage me or, in not so many words, tell me my work wasn't good enough. If I had for one moment listened to them and stopped creating, you would not be reading this book. But I didn't listen to them; I listened to me. I let their discouraging words be the fuel in my fire to prove them wrong. I would continue creating and believing in my work regardless.

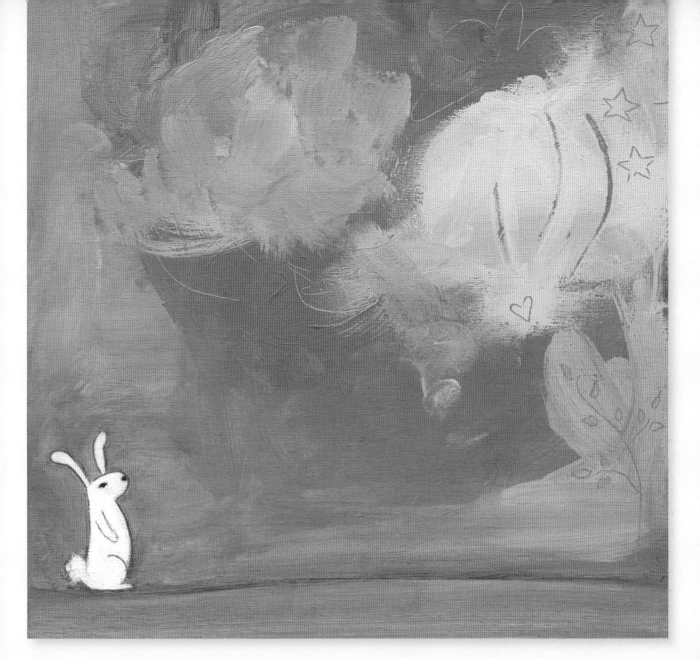

Often we have an initial feeling about something, but we sway it, or morph it to fit in with whatever group we currently want to be accepted into. This is not to say that being genuinely open to others' opinions and ideas isn't a nice trait to have. It is. We are all different, and being open to our differences can inspire, and challenge, our thoughts (and art) further. However, just be sure to acknowledge your first response to anything, which doesn't mean that your first response is always accurate, but it will give you more clues about who you are. This is also referred to as listening to your intuition, your heart, your gut.

Those who have become great leaders and creative visionaries have often been the first to follow a belief that very few, if any, had. They were willing to pave the way for us because they knew who they were and were not willing to compromise their beliefs so someone else would understand or like them better or even support them on their journey. They just believed and went for it.

Chances are, if you are ready to open up more to your creative self, or you are already accessing your creativity, you are a visionary. Artists transform the world. Sometimes I wonder what the world would be like if we were all tapping into our inner artist.

So are you spending enough quality time with you? Are you listening to your intuition? If you want to get to know someone else, you spend time with them, and you listen closely to what they are sharing about themselves and their ideas, right? This is what you want to do with *you*. If your life is full and surrounded by others with very little time for yourself—especially time alone—it may mean that you have been avoiding getting to know yourself.

This can be scary for those of us who have spent years fitting in, doing the "right" thing for everyone everywhere and saying yes to everything that is asked of us. No matter where you are on your journey, you have to be willing to ask yourself some questions to reacquaint yourself with *you*. These may be questions you have been avoiding for a long time, but your creative voice lies within the answers. If you want to *express* who you truly are, you must *know* who you truly are.

Visit www.createmixedmedia.com/creativethursday for more creative ideas.

While the questions I've included for you here seem simple, thinking about them can unearth a lot. Sometimes your answers might not fit with your current lifestyle, which might mean that your life is ready for some big changes. So, it is important for me to note that you are in control here, and you don't have to make any changes that you are not ready for. Asking the questions and contemplating the answers only means that you will be thinking about something new; it doesn't mean you have to take action immediately.

Asking and answering questions throughout your life invites expansion, clarity and . . . change. If that is unsettling, it's understandable. But, ideally, we all want to grow to the place where this feels exciting for us, where we welcome each and every opportunity to evolve and change because that is what is life-giving and what inspires our creativity.

As much as there are days when I wish that I could just figure it all out once and for all, I now know that continually searching for and finding the answers is what feeds me. Life is an ever-evolving journey that we take. So let's have more fun with it all, and let's use it to endlessly feed ourselves and our art. I was watching an interview with famed American portrait photographer Annie Leibovitz, who after almost forty years of continuously exploring photography still comes across new ways to pursue her art. She said that every time she tries something new, she realizes "just how deep that well really is."

The Questions

When you don't even know how to begin to tap that well that Annie mentions, you can always start with questions like the ones that follow. These same questions have different answers at different times throughout your life. The answers change as you evolve.

Before you look over these questions, take a moment to be still. Set yourself up in a comfy, cozy chair. Take a conscious breath. Set an intention to be open to your own intuition. Learn to listen and recog-nize it as it tries to guide you in the direction you most want to go. Also, don't feel like you have to have the answer to any one question right away. There is no right or wrong here, and these questions do not need to be answered all at once or in any particular order. These questions touch on many aspects of your life— not just those that deal with creative time or making art. Start with a willingness to simply ask the question and you will know the answer when it comes.

Visit www.createmixedmedia.com/creativethursday for more creative ideas.

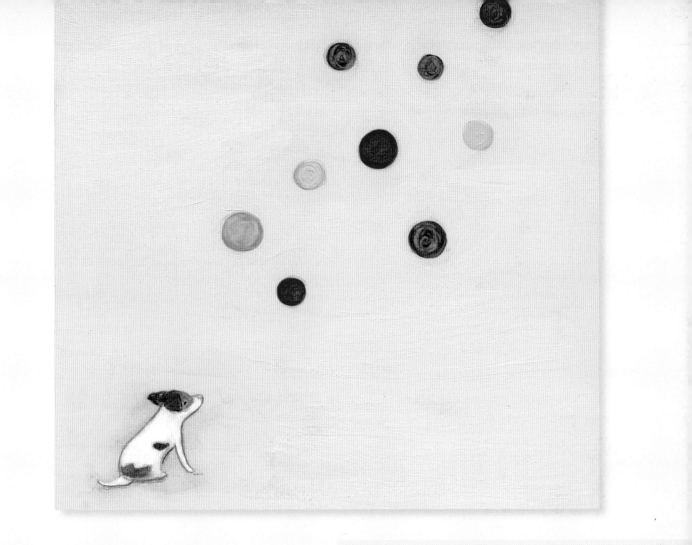

No matter where I presently stand, I find these questions endlessly helpful. I hope they can provide you with guidance and clarity, and can instantly reconnect you with you.

What are you working on when you lose all sense of time?

What are you doing when you feel your best?

When was the last time you felt great about yourself? What were you doing?

What kinds of creative projects are you working on when you feel most fulfilled?

What did you most love to do as a child?

What is/are your favorites:

- Color(s)?
- Animal(s)?
- Place(s) to visit?
- Place(s) to live?
- Season(s)?
- Climate(s)/geographical region(s)?
- Food(s)?

- Form(s) of exercise?
- Event(s)?
- Music?
- Movie(s)?
- Television show(s)?
- Book(s)?
- Type(s) of art?
- Artist(s)?

Dig a little deeper now, and ask yourself why these things are your favorite. For example, why do you love swimming in the ocean? Why do you prefer a trip to the beach versus a hike in the mountains? Why do you prefer orange to purple? Why do you like blueberries instead of strawberries, or berries instead of oranges, or fruit and yogurt instead of cereal for breakfast? Or do you just like chocolate chip pancakes?

Now that you've gotten started, here are some more questions to ponder:

Who are your heroes? Why are they your heroes?
How are you honestly, genuinely feeling about yourself?
How do you feel about yourself in relation to your work right now?
Are you feeling confident or a little vulnerable?
Are you feeling a little deflated, or are you inspired?
Are you doubting yourself, or are you sure of yourself?
When you create something you love, what is "that thing" that makes you love it so much?
What does success mean to you?
What does your ideal life look like? (Think about every last detail. Who are you sharing it with? Where do you live? What does your home look like? What furnishings do you have? What clothes do you wear? What kind of work are you doing? How much freedom do you have? What do you do for fun? How do you feel day-to-day?)
What is working right now?
What is not working?
How might you take even better care of yourself?
Where would you like to be, how would you like to feel, what would you like to accomplish by the time you finish this book? How about six weeks from now? One year from now? In five year? In ten?

Visit www.createmixedmedia.com/creativethursday for more creative ideas.

Watch your voice evolve.

Of course, once you find your voice, it does not end there. Just like you want to stay open to how your life evolves, you also want to stay open to how your creative voice wants to evolve within your life.

If you are engaged in life, and with your creativity, you will always be able to hear your voice calling you forward.

No matter how you grow, the essence of you will always shine through. In fact, you can't get away from your creative spirit once you find it. And you won't want to, because accessing it will always feel the most fulfilling. It will force you to stay true to yourself, even if that doesn't fit with the current trends. Remaining connected to the core of who you are is what will sustain a long and happy creative life.

Knowing yourself this well will continually provide you with that grounded foundation to return to for support, encouragement and reassurance to forge ahead, even on the days when you temporarily lose your way. It is always a good idea to check in from time to time to see if where you are and where you are headed is still leading you to where you want to go. And remember to keep a willingness to change course when your original ideas no longer fit the person you are now.

In Search of Encouragement

I touched upon the idea of accountability before, and I want to revisit it here because it made such a huge difference for me in growing my creative practice. When I started posting my paintings to a blog daily, it all changed for me. This was the kick start I needed not only to start painting but to keep painting. Years later, I am still excited to share my newest creations on my blog.

Inviting others to follow along with you on your journey keeps you creating—it does. However, there is a flip side. The flip side is that eventually you can get to the point where you worry too much about whether your dedicated audience will like what you share. We walk a fine line to keep that balance of inner strength while we share what is nearest and dearest to us.

Inviting others to view your work is a big step. Once the days of pure, blissful, unconscious creating you experienced as a child are behind you, it can take a long time before you start feeling confident enough to share your work with others. It took a long time for me.

There are moments when I question something I've made, but thankfully it only lasts for seconds, like some residual self-doubt desperately trying to hang on from the past. I try not to take those moments of doubt too seriously. Try to see these moments of your own doubt as reminders that you care deeply about your work, that you are always striving to evolve, become better and create something you are extremely proud of. That sense of pride can ultimately override any residual doubt, and the love you have for your creations will return.

That surge of love you feel for your work—that is when *you know* you've created something good. (Note the emphasis on the words "you know.") One more time: Art is subjective. Someone else might think that what you have created is not good, but if you are happy with it, that is what matters most in your creative process. How have I come to this conclusion? I have had several people along the way discourage me or, in not so many words, tell me my work wasn't good enough. If I had for one moment listened to them and stopped creating, you would not be reading this book. But I didn't listen to them; I listened to me. I let their discouraging words be the fuel in my fire to prove them wrong. I would continue creating and believing in my work regardless.

Love What You Make

If I love what I make, then I've fulfilled my creative process. If others also love what I make, that is like the cherry on top of the whipped cream. It's a wonderful feeling to have someone else share the same love for your creations that you do. Honestly, to create work you love as a career and have someone love it enough to buy it—there is nothing better.

That said, our self-esteem and self-worth cannot be dependent upon what others think about our work. For one thing, there will always be people who will love what we create and those who won't. In fact, they may not even remotely like it. If we are up when others like what we make and down when they don't, that can result in quite a roller-coaster effect on our emotional well-being. And I don't know about you, but I find it very difficult to create from that state. We want our emotional well-being to operate independently from what others think, not only about our art but about everything. This is why I put so much emphasis on

loving what you create (and loving yourself). I can fulfill that. And if I love it, I know that this is the best I can do. And that is all. The life my creation leads after that is out of my hands.

True creative fulfillment exists when you absolutely love what you make. It may not happen instantly—especially if you are not yet comfortable in your creative skin or if you are still creating from a place of trying to please someone else. Some of us reach that comfort level more quickly than others.

So at what stage of a piece should you actually like it? Very often a piece is just too new to fully appreciate it early on. This also varies from person to person. Sometimes you may not like a piece the entire time you are working on it, and you only like it when it's finished. Some pieces you like best at the very beginning, and there will be ones you may never like at all. You might need a little time and perspective to see that what you created is something special. A little seasoning, perhaps. Often I look back on work I created a few years ago and I love it even more now. Will you be

challenged sometimes? Yes, of course. Will it feel hard on some days? Absolutely. But following youb bliss is what you're after. If at least some part of the process doesn't ultimately bring you joy, then why create?

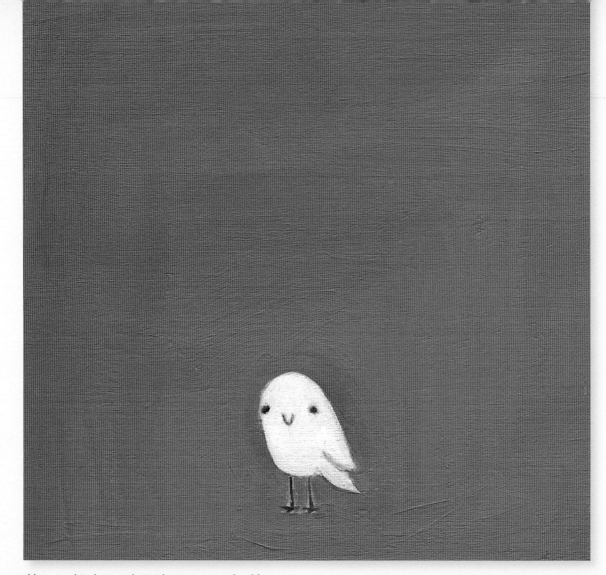

You need to be *ready* to share your work with others. Certainly you can create happily without ever sharing it with anyone. But I believe that sharing it is a necessary step to becoming your whole creative self. Sharing it with a detached sense of how it will be received is ideal. But this is not to be confused with a lack of excitement in sharing it. As I mentioned before, I always feel a sense of excitement when I share something new with the world, but I always have to remember to simultaneously let go of any expectation of how it will be received. If you can accomplish this balance, you know that you are truly creating for yourself. If I were to strip this book down to the bare bones, that would be the message. *This is about creating for you.* Whether professional or hobbyist, never lose sight of the fact that this practice is always about creating *for you.* Tune out other's ideas of what life is *supposed* to be, and tune into your own voice.

Visit www.createmixedmedia.com/creativethursday for more creative ideas.

Begin to Share

Share with friends and family.

When you do feel ready to share your work with others, choose those who live in their truth and are unconditionally supportive and encouraging. This is a good practice for everyone expressing themselves creatively, but it's especially vital for someone just beginning to share his work. Regardless of what some teaching methods condone, it does not make you a better artist to have input from anyone who would knowingly or unknowingly try to tear you and your creations down. We do not want to shun critiques and guidance to push us further, but who we solicit guidance from must be carefully and thoughtfully chosen.

Take classes.

Deciding which creative class to participate in and which teachers to learn from must also be given the same care and thought. The wrong teacher can break a creative spirit, just like the right teacher can make it flourish. If you are attending college, you might not have that choice when it comes to selecting your teachers; you might just get who you get. And sometimes that's OK, too, because we all need to learn from those experiences that maybe are not so ideal. I ended up with several art teachers in college that although they taught me new skills, their critical, judgmental approach did not do much in supporting me to pursue my art. In fact, I almost let them snuff out my creative spirit. But as I mentioned before, I needed those experiences to remind me how much I wanted to take this path, to push me to find my own way, to prove them wrong.

In my black-and-white photography class in college, I presented a series of photographs featuring snippets of my cat. No matter what I shot, my cat seemed to find a way into the frame. I thought it was hilarious, and I think my teacher may have found it mildly amusing. But what I remember most was that she closed the critique of my project by telling me, "Cute doesn't sell." As it turns, my entire business has been built on cute. She was wrong.

I recommend choosing skilled, encouraging and nurturing teachers and mentors. Learn from those who inspire you, who lead by example. This also applies to creative retreats that you attend. Be sure to choose the ones led by people who want to provide a safe and encouraging learning environment. With so many of us having a mouthpiece these days, I find that many talk the talk, but few actually walk the walk.

Visit www.createmixedmedia.com/creativethursday for more creative ideas.

Try to avoid comparison.

Oh, what do we do when we feel like who we are and what we are doing are not good enough? Comparison can be the silent killer of the creative spirit. Yes, healthy competition can make us strive to be better, but comparison does the opposite. It shuts us down. It makes us question everything. It makes us lose our footing, and it makes us less compassionate toward others as we begin to see their successes in life as a threat to our own success and self-worth. Not good. Not good at all. And let me tell you, there are many highly successful, well-established, professional creatives who still deal with this from time to time. The difference is they know how to acknowledge it, move past it, ignore it entirely or, better yet, use comparison to feed their inspiration.

As I mentioned before, advances in the world of "all things online" are wonderful and inspiring. We now get a glimpse into the lives of people all over the world, and in that glimpse, a lot of people appear to be living the perfect life (perfect for them). And they might be! Or, as with all edited content, it may just be an appearance of the perfect life. None of us really know what anyone's life is actually like, day in and day out, unless we become that person and not only step into their shoes but live inside their head. So the question is this: Why are we comparing ourselves, our talent, our lives to another's? Why are we using one more thing as an excuse to not fully appreciate and honor ourselves? I do not have the answer for that, other than to suggest again that this is probably a product of our school system with grades and stars and trophies for good behavior above and beyond someone else. I'm not saying that achievements shouldn't be rewarded, but it would be great if it weren't at the expense of someone else's lack of achievements. Some competition is healthy and necessary. In fact, sometimes not excelling at something is exactly what points us in the direction of what we will excel at.

It may be too idealistic to assume that we could all unconditionally support one another as we all thrive, but that would be nice. Or what if we chose to be in competition with ourselves instead of each other? I heard an analogy recently that goes like this: If life is like a race we are running, then every time we look back to see if someone is catching up with us, we lose a little bit of our energy and focus in running our own best race.

If comparison and feeling jealous of another is continuously getting you down—if it starts to consume you—turn it around. Realize that when you feel jealous of another, it just means that you want what they have and some part of you doesn't believe you can have it. What if you did believe you could have what you want and you used those you are jealous of as inspiration to keep reaching for what you want? Instead of resenting or criticizing them, you can put all of that energy to better use, by being creative.

Enjoy tokens and totems.

I was hanging my little elf ornament on my Christmas tree when I suddenly remembered that when Creative Thursday was in its infancy, I had chosen that elf as a symbol for all that I envisioned my business would become. Now you might be wondering, why would an entire business vision be encapsulated into one tiny elf ornament? I don't know, but it is. Something about the colors, the gift he is holding, the whimsy of the design and the friendliness of his little face became the symbol for the feeling I imagined my business would encompass. As I hung him on the tree this year, I realized that my business has become exactly what I envisioned. When I first found that elf, I hadn't even started painting characters yet; I had just started designing and painting my vintage chairs. You can never underestimate the power of a totem.

Visit www.createmixedmedia.com/creativethursday for more creative ideas.

I have always surrounded myself with tokens that become symbols of where I want to go and who I want to become. For instance, when I want to feel more prosperous, I drink from one of my first-ever ceramic cups that I designed. I call it the "prosperity cup," and it works! I feel more prosperous every time I drink from it.

Just recently I came across a vintage brass figure of a deer (or it may be a donkey or dog) right at a time when I desperately needed a reminder to trust more. I decided that every time I look at that figure, I will remember to trust that everything is always working out just as it should. I put that figure into a painting as well.

We need little treasures to remind us every day to stay focused, encouraged and headed in the right direction (for us). Look around your space. What do you see that makes you feel excited about where you are or where you are going?

Are you surrounding yourself with imagery and tokens that energize you or deplete you? Our physical space has a huge influence on how we feel every day. I'm a big believer in the power of decluttering and letting go of anything and everything that is weighing you down—physically or mentally.

Create some physical space around you so that the belongings you do have are all ones that you truly cherish. Choose some of those everyday items, like your jewelry or clothing or dishes, to be a symbol of the very best of your life. This way, when you look at them, wear them, or drink from them, you'll always be reminded of the positive things they represent for you.

CHAPTER NINE
Tracking Progress

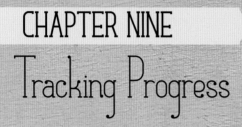

When you make creativity part of your regular routine, you begin to develop a body of work. You can literally see the progress as you go. Maybe a stack of paintings begins to grow in your studio, or the pages to your book are really stacking up, or you now have a line of jewelry or a collection of fabric, or the sock you have been knitting (for over a year; that would be me) is finally finished!

I think it is all too easy to get overwhelmed anytime we think of bringing a creative project to completion, especially one that takes time to build. But when you consistently and consecutively add up small moments of creating, you will be amazed at what you will have before you.

This is where I believe that in the age-old story of the tortoise and the hare, it's best to be the tortoise. A fulfilled creative life is built from a slow and steady foundation. You do not end up burning yourself out. You allow your creative process to evolve organically at its own pace. You become an observer as much as you are a participant. You find joy in your creative process, and you trust that it is all working just as it should, in a timing that is perfect for you.

Dipping Into Your Creative Wellspring

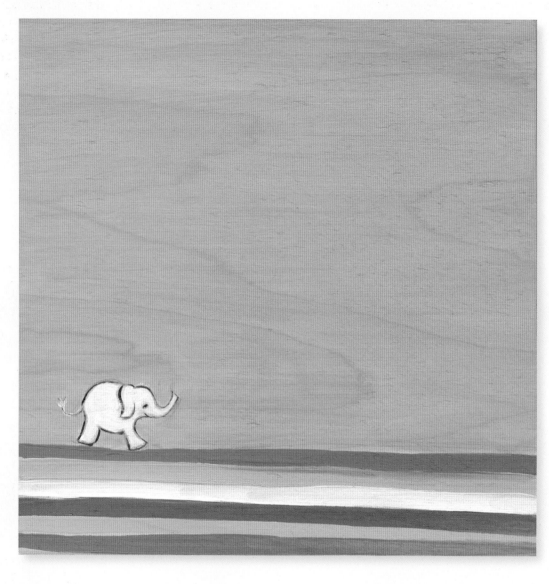

Stockpile your great ideas.

A positive side effect of all this consistent creating is that you will see just how much *creativity inspires more creativity*. Once you open the doors—and keep them open—a steady stream of ideas begins to come. It's almost as if you can't stop the stream. The more you try to keep up, the more the ideas keep coming. This is the time to keep that idea journal and/or sketchbook (or smartphone or napkin) nearby. It is a truly fantastic feeling to be in that flow, and once you become comfortable and familiar with your process of accessing it, even if you have an inspirational slump, you will always know how to find your way back. You will no longer panic when an inspirational drought surfaces and you will simply take the time to rest and regroup.

Visit www.createmixedmedia.com/creativethursday for more creative ideas.

Enjoy more than one discipline.

One question I hear often from my students is, "Do I have to choose just one discipline?" I believe that what many of us are reaching for in life is to express the fullness of our unique brilliance. And for the purposes of this book, we are reaching for our creative brilliance. All disciplines that help you reach that place are worth pursuing. So my answer to the above question, is *no*, you do not have to choose.

This topic matters a great deal to me because for so long I felt conflicted that I had so many interests! You know the familiar label, "Jack-of-all-trades, master at none?" I think it needs to change to "Jack-of-all-trades, master at accessing creativity and good at all." Today we see so many people, often self-taught, who are good at everything they touch. Honestly, if you want to see just how possible that is, hop online and visit an artist's blog.

A creative person can be a great writer, make wonderful art, take beautiful photographs, style them irresistibly and share them on an elegantly designed blog. She can throw a fantastic party in her charming home with a menu made from her own recipes while wearing clothes she designed, knitted and sewed herself—all with a baby on her hip. It's true! OK, maybe not typically all at the same time . . . but there are some who seem to pull all of this off simultaneously in an effortless way.

I know this brings up another question: "How *can I* do it all?" The answer is by taking advantage of the opportunities that present themselves all the time. Every moment, every choice you make in your day is a chance to access your creativity. I'm not suggesting an overwhelming stretch-yourself-thin, try-to-be-perfect-and-make-yourself-crazy-and-exhausted kind of way, but in the care you give to the details of your daily life. Why not reach for your best? Start your day by checking in with yourself and notice what ideas *feel* best for what you'd like to create today. Don't limit yourself by choosing what you know best or avoiding what you think you don't know enough about. Just know that creating in whatever medium excites you the most will absolutely inform and inspire all the other mediums.

One of the best examples of this practice is filmmaking. Writing, acting and directing are all different disciplines—each an art form in its own right—yet they all work together to create one piece of art. And for those who cross over, working in all three disciplines, they know just how much one strengthens the other.

Take, for example, a chain of my creativity, started by sewing a softie. This was a skill I was not very practiced at, yet, I felt incredibly inspired one day to not only sew a softie but to illustrate its face with free-motion stitching using my machine. The result: Miss Fran.

Miss Fran was so cute as a softie that I had to paint her portrait, her ric rac scarf flowing off to her side. (Later, this also became an image for one of the months in my annual calendar.)

I then sculpted her in clay, the ric rac scarf still a must in her wardrobe! Then she inspired one of my favorite designs in my second fabric collection called "Ric Rac Rabbits." Who knew Miss Fran would inspire so much? She may not even be finished yet because I still have a few ideas up my sleeve . . .

When I sat down to illustrate with my sewing machine for the very first time, I had no idea that my creation would become a catalyst for so many designs. Sometimes it is best not to know this because if you knew so much was going to stem from one idea, you might put far too much pressure on yourself to create just the right piece, instead of just having fun creating. But this goes to show that you never know where the next idea will come from or what it may become. That little crayon sketch you made at dinner on the paper tablecloth at the restaurant might be your next great idea!

Visit www.createmixedmedia.com/creativethursday for more creative ideas.

Developing Skill Over Time

The artist who practices regularly becomes better at his craft. Malcolm Gladwell brought attention to this idea of the 10,000-hour rule in his book *Outliers*. This is the suggested number of hours someone must practice to become an expert at his or her craft. That is a lot of hours, but totally doable (even when you enjoy working in more than one medium!). I find truth in this philosophy. Imagine how comfortable you will be with whatever you pursue when you put that kind of focused attention and time into it. And the truth is, when you find something you love that much, you won't even be paying attention to the specific amount of time you are putting in. In an age where instant everything is the new norm, do not lose sight of the value in giving something time.

You will learn; you will evolve; you will develop your style. My characters were only revealed to me through time and regular practice. The challenge to continuously come up with new ideas can encourage an entirely new painting style for you as it did for me. Be willing to do the work, and remain open to what your creative process wants to become.

Think of creativity as meditation.

When developing a regular creative practice finally becomes a new habit, creating becomes an addiction in the healthy sense of the word. You will not want to go long without practicing, and you will feel it immediately when you do. Being creative will become like a meditation for you—a time for you to connect with you.

Over the years, creativity has become my safe haven, my time to be still and nurture what it is that I need. Focusing my mind on my art gives it a break from everything else—especially worry.

Visit www.createmixedmedia.com/creativethursday for more creative ideas.

Even as an entrepreneur with a growing business, I know that making time for creativity is more important than ever—not only for my mental well-being, but because it also sustains my business. This also means that it is important to keep the lines between business and creativity separate.

You must remember to create with a pure heart, for the fun and the joy of it. On most days you will probably find this easy to do. In fact, when I sit down to be creative, it instantly grounds me, reminds me of what is most important and helps me keep everything in perspective. I breathe a sigh of relief because I know that I've made the choice to care for myself and feed what inspires and energizes me. I think when you do this—especially if you haven't been honoring this time enough—you'll find that you'll feel instantly better, too.

CHAPTER TEN

Stepping Outside Your Comfort Zone

So it's here! You have found your voice and you are
becoming a master of your creative practice—for now.
And I say "for now" because there is no end to this
journey. Just as you find your way, there will be some-
thing new to learn. You can resist or allow or, better
yet, encourage this part of the process; once again,
the choice is yours.

To encourage this process, you must be willing to
step out of your comfort zone.

First, be OK with the discomfort of leaving your
comfort zone. Leaving your comfort zone means step-
ping out of what is familiar, and, as we know, stepping
out of the familiar will feel slightly awkward. I just want
to reassure you that it is completely normal to feel
completely out of your skin. If you are not feeling out of
your skin every so often, then you are not growing.

I heard recently that as humans, we are happiest
when we feel like we are progressing, and I know this
to be true for creatives. Creativity is about accessing
innovative ideas, and those come only when we are
open to progressing as people and artists. The thrill
of a new idea pouring out—especially in the middle of
expanding your awareness—is awesome.

Those moments of discomfort just before the new idea though . . . they can be tough. They can cause us to question ourselves, doubting our intent and our direction. And if we are not careful, we can get swept away in these thoughts, retreating from the brilliance we are meant to step into.

It's not the end of the world if we do get swept away from time to time, of course. We just don't want to get swept too far away for too long because this uses valuable energy that could be better spent creating. I want to emphasize that this is all part of the process, and it happens to the best of us. We have to learn how to maneuver through those particular times of doubt and uncertainty, and recognize them, remembering to be especially soft with ourselves and accept those moments for simply what they are—a chance to grow. Because I recognize those moments much more quickly now, I have learned to transform the energy to inspire my creativity rather than detract from it. Then again, some days I need either a good chat with a friend, a glass of wine (or two), a nap or all of the above.

Visit www.createmixedmedia.com/creativethursday for more creative ideas.

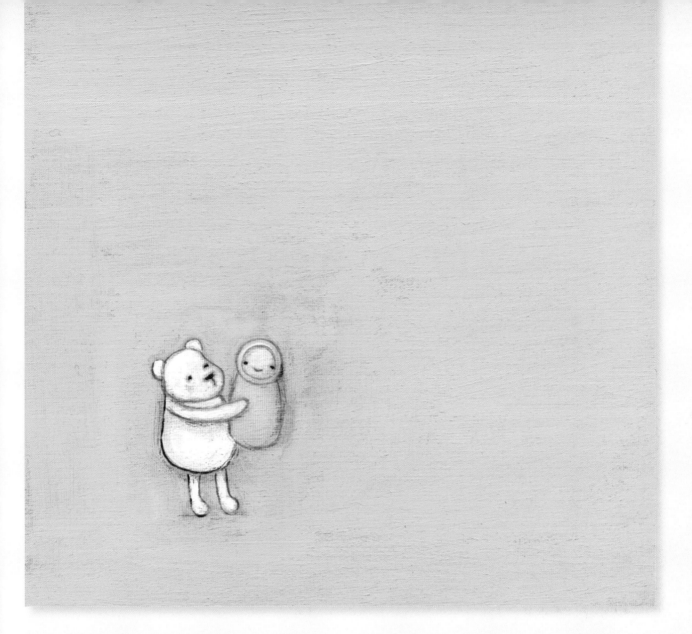

Sometimes turning those dark feelings around while they are happening is challenging, but the upside is that the inspiration that follows those times is usually filled with a lot of clarity. Once I'm on the other side, it always feels completely worth whatever awkwardness it took to get there. Remembering this while I'm experiencing the awkwardness is key.

As our awareness grows and our world becomes more and more complex and involved, you, like me, might long to return to a simple existence where you reach a place of contentment with your art and just stay there—a way to put the genie back in the bottle. But the genie cannot go back in. And, in all honesty, we would get bored if we did achieve a constantly content state because, as creatives, we are programmed for more! That is what we are here for. We are continuously carving a new path. Artists have always been the ones to see slightly ahead of their time and lead everyone to a new vantage point. Seriously, again I ask, where would we be without artistic vision?

If you let yourself stop growing and get swept away in negative feelings, you are not only doing a disservice to yourself but to all of those individuals out there who would benefit greatly from what you have to share with them!

We all know so much now. We all know that we can reach for more than we ever thought possible. With that knowledge comes the need and desire for expansion, and that expansion only comes with a willingness to continually step outside of our comfort zone.

Ideas for Stepping Out

IN NO PARTICULAR ORDER OF IMPORTANCE,
HERE ARE SOME IDEAS TO ENTICE YOU
TO STEP OUT OF YOUR COMFORT ZONE:

- Take an art class in a new medium.
- Make a new friend.
- Try a new sport or exercise routine.
- Take a new route home.
- Pick out an entirely new outfit combination to wear.
- Take up vegetable gardening.
- Rearrange your studio space or your entire home.
- Perform something on stage in front of a live audience.
- Take an improv class (I highly, highly recommend this).
- Teach your own class.
- Use a new lens on your camera.
- Walk or bike somewhere rather than drive.
- Go out to a new restaurant.
- Shop at a new store.
- Paint BIG!
- Paint tiny.
- Use new color combinations.
- Use new brushes.
- Write poetry or write a song by hand on a notepad.
- Cook Indian food or a new Thai dish or fried chicken.
- Bake a pie and make a lattice crust from scratch.
- Learn a new instrument.
- Take a dance class.
- Crochet a granny square.
- Knit something.
- Take a singing class.
- Learn to sew.
- Learn to surf.
- Learn to dive.
- Skydiving perhaps?
- Travel.

Visit www.createmixedmedia.com/creativethursday for more creative ideas.

It's so easy to step out of our comfort zones when we are traveling and much trickier to maintain when we are living our usual routine. After we lived overseas in Paris, for a month, we felt so alive, invigorated and inspired. When we came home, we had big intentions of keeping that feeling alive and exploring our home city from an entirely new perspective. So, it surprised me how quickly we slipped back into our usual routine.

The familiar is good, comforting and necessary sometimes, and focusing inward in a secure environment is exactly what we often need. Just be aware of when you are using the familiar as an excuse to avoid stepping out.

Leverage Your Art

After you've found your creative voice (and even while you are trying to finding it), oh, the possibilities. As I shared before, I feel endlessly thankful to have found what I love most in this world. The question I now have is not, "What am I going to do with my life?" but "How am I going to fit in everything I want to do?"

There are so many directions we can take with just one creation. And now, more than ever before, we can bring any one of those ideas into fruition with just the click of a button—astonishing and incredible. If there is something you really want to create in this world, there is nothing stopping you except you.

Visit www.createmixedmedia.com/creativethursday for more creative ideas.

Do you want to make prints, canvases, calendars, clothing, cards, magnets, journals, shoes, phone covers or dishes with your art or designs on them? You can! Do you want to transform your art into designs for stationery, wrapping paper, fabric, stamp sets? You can! Do you want to make your own jewelry? You can! Do you want to write and record and make a video of your own music? You can! Do you want to make your own film or sketch comedy piece or an episodic show? You can! Do you want to perform live on stage? You can! Do you want to design your own clothes? You can! Do you want to have your own cooking show? You can! Do you want to become a photographer or a photo stylist or both? You can! Do you want to design your own home or garden or both? You can! Do you want to write a book? You can! Do you want to develop your own knitting, crochet or sewing patterns? You can! Do you want to make your first quilt? You can! Do you want to open your own shop in your neighborhood or online? You can! Do you want to share any of these options with people all over the world? You can!

OK, the list is endless. Do you get it? I mean really get it? The list is *endless*. You have no excuses. The world is your oyster. Now go forth and create. I, for one, will always be here cheering you on.

Visit www.createmixedmedia.com/creativethursday for more creative ideas.

And the day came when the
risk to remain tight in a bud was
more painful than the risk it took
to blossom.

<div align="right">— ANAÏS NIN</div>

Final Thoughts

This is the part of the book-writing process where I fast and furiously run through all the years of my life and the tiny notes scribbled on legal pads kept over the months of working on this that say, "remember to tell them this," with the hopes that I have finally shared everything with you. And I know the minute this book goes to print, there will be just *one more* thing I want to tell you . . .

And that's also just me (you should see how challenging it is for me to end a good conversation, let alone say goodbye), constantly evolving, always excited about what's next and always excited to share it with someone.

I'm guessing that however you made it to these final thoughts—reading the book from cover to cover or randomly skipping through the pages—you and I, we share a love for creativity. I know that keeping it accessible and a priority is going to be a necessity for us. Whether you're just starting to embrace this truth in yourself or you have been for a long time, I hope that what I have shared with you continues to inspire and encourage you further.

This is also the part of the book where I want to leave you with something profound and unforgettable;

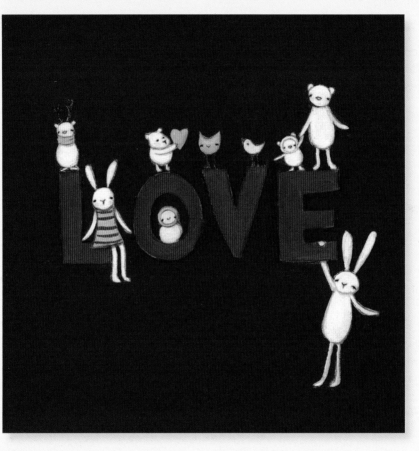

a moment to sum up everything I've shared in just a few meaningful words and sentences; something you can remember forever and keep with you in your pocket on the days when you need that gentle reminder to keep going.

My wish actually: that this entire book will be that for you for years to come; that it might sit by you among your most treasured belongings, where, whenever you feel like it, you can randomly open to a page, and the images or the words will speak to what you are most needing to see or hear that day.

So I will end as I began.

I believe everyone is creative. I believe all of us are meant to step into the fullness of who we are to become. I believe that when we do, we really start living and experiencing even more of the joy that we are all after.

Remember, I will always be cheering you on.

Much love and creativity,

Marisa

Resources

Supplies

Andover Fabrics
andoverfabrics.com
they carry my fabric line
Art Boards
art-boards.com
all my art boards come from here
Fancy Tiger Crafts
fancytiger.com/craftindex.html
ric rac and trims
OhMa Felt
ohmafelt.com
felt used on softies
Purl Soho
purlsoho.com/purl
threads and fabrics
Sew LA
sew-la-fabric.com
Japanese fabrics

Art and Artists Featured

Happy Abby
etsy.com/shop/abbyjac
wood figure on page 100
The Little Red Door
etsy.com/shop/thelittlereddoor
three houses on 46
Lizzy House
lizzyhouse.com
snowflakes on page 36
Outi Harma
outiart.com
cups on page 36
Kayo Horaguchi
kayomaru.com
fabric on page 108
Orla Kiely
orlakiely.com
cup on page 61

Creative Thursday Sites

Creative Thursday Website
creativethursday.com
Creative Thursday Etsy Shop
creativethursday.etsy.com
Creative Thursday Blog
creativethursday.typepad.com

Inspiration

Books
The Artist's Way by Julia Cameron
Walking in This World by
Julia Cameron
Fanciful Felties by Samantha
Cotterill
Dottie Angel by Tif Fussell
Outliers by Malcom Gladwell
All Tricia Guild books
You Can Heal Your Life by
Louise Hay
Ask and It Is Given by Esther and
Jerry Hicks
Handmade Living by Lotta
Jansdotter
Pattern by Orla Kiely
Clear Your Clutter with Feng Shui
by Karen Kingston
Paumes books, specifically *A Girly
Interior in London*
A Whole New Mind by
Daniel H. Pink
The War of Art by Steven Pressfield

Make Your Creative Dreams Real
by Sark
Living the Simple Life by Elaine
St. James

Documentary Series
*Visionaries: Inside the Creative
Mind,* OWN TV, featuring Annie
Leibovitz

Music to Create To
Bon Iver
"Claire de Lune" by Debussy
Coldplay
Radiohead
Sigur Ros
Soundtracks (a favorite is *Shopgirl*)

Magazines
Anthology
Mollie Makes
Stampington Publications
Sunset
Uppercase

Design Blogs
bkids.typepad.com
creaturecomfortsblog.com
designlovefest.com
ohjoy.blogs.com
poppytalk.blogspot.com
sfgirlbybay.com

Index

16 15 14 13 12 5 4 3 2 1

Distributed in Canada by Fraser Direct
100 Armstrong Avenue
Georgetown, ON, Canada L7G 5S4
Tel: (905) 877-4411

Distributed in the U.K. and Europe by
F&W Media International
Brunel House, Newton Abbot, Devon, TQ12 4PU, England
Tel: (+44) 1626 323200, Fax: (+44) 1626 323319
E-mail: enquiries@fwmedia.com

Distributed in Australia by Capricorn Link
P.O. Box 704, S. Windsor, NSW 2756 Australia
Tel: (02) 4577-3555

Editor:
Tonia Jenny

Designer:
Geoff Raker

Production Coordinator:
Greg Nock

fw
media
www.fwmedia.com

About Marisa Anne

Photo by Lisa Occhipinti

Marisa Anne Cummings is an artist and textile designer living in Los Angeles, California, with Sean and Garbo. What started out as a desire to be a bit more creative one day a week while working a nine-to-five job, Creative Thursday grew into a full-time business (and a dream come true) featuring Marisa's art, fabrics and now this book that you are holding in your hands.

She believes there will be more happiness in the world when everyone is creative and finds fulfillment in doing work and living a life they love. Marisa hopes that this book will be one small contribution to that greater vision, inspiring and encouraging everyone who reads it.

You can visit Marisa at creativethursday.com

Dedication

Everyone who has heard the call of creativity, those who are already answering it~ and those who are just beginning.

Acknowledgments

A book never gets written alone, so a moment of thanks.

Thank you to Sean, who has been by my side since the beginning of this adventure; for his love, support, and inspiration, and for still smiling at every creation I make.

Thank you to my Mom, Erika, for being a woman ahead of her time, a great mama, for teaching me to believe in what is possible and always reminding me to just be myself.

Thank you to my Dad, Robert, for having lead by example and shown me what it meant to live a life doing work that you love.

To my Oma Edith and Opa Erwin, Ingrid, Gerdi, Helmut and Louise, Susanne and Sabina; thank you for inspir-

ing me, showing me so much unconditional love and for recognizing and always encouraging that spark of creativity and imagination early on.

To my creative girls, my friends, my sisters in creativity and entrepreneurship—you know who you are—endless thanks for all of your inspiration, support and encouragement always (and special thanks to Jen who was there for the very first Creative Thursdays).

To my editor Tonia for finding me, "getting" me instantly, honoring my voice and my art and making this process of writing my first book so seamless and lovely.

And, thank you to Garbo, my muse, who is always there to remind me not to take things too seriously and love my life more.

createmixedmedia.com

Connect with your favorite artists.
Get the latest in mixed media inspiration,
instruction, tips, techniques and events.
Be the first to get special deals on the products you need to improve your mixed media
endeavors.

These and other fine
North Light mixed media
products are available
at your local art & craft
retailer, bookstore or
online supplier.
Visit our website:
CreateMixedMedia.com.

 **Follow CreateMixedMedia for the latest
news, free demos and giveaways!**

**Follow us!
@CMixedMedia**

**Follow us!
CreateMixedMedia**

Inspire your creativity even further with these North Light titles.

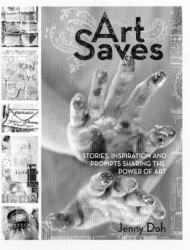

The Pulse of Mixed Media
by Seth Apter

Indulge your voyeuristic side as
you see inside the hearts and
minds of more than 100 artists
as they share their art, thoughts,
confessions and insights about
the creative community.

Desire to Inspire
by Christine Mason Miller

Embark on a global expedition
and see what creatives are doing
the world over to inspire others to
make a difference.

Art Saves
by Jenny Doh

Experience the stories of 20
artists who found that artistic
expression is worth living for.